DEGAS
AND THE ITALIANS
IN PARIS

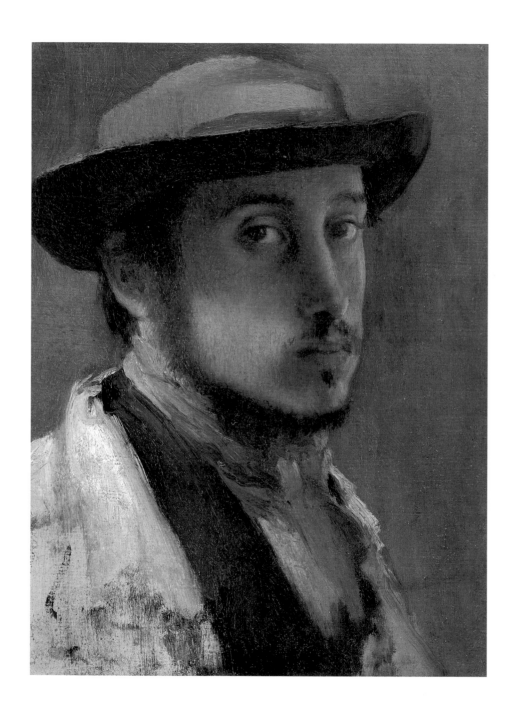

DEGAS

AND THE ITALIANS IN PARIS

ANN DUMAS

NATIONAL GALLERIES OF SCOTLAND

EDINBURGH 2003

Published by the Trustees of the
National Galleries of Scotland on the occasion of the exhibition
Degas and the Italians in Paris held at the Royal Scottish Academy
from 12 December 2003 to 29 February 2004

ISBN 1 903278 48 1

Designed and typeset in Bodoni Old Face by Dalrymple
Printed by Snoeck-Ducaju & Zoon, Belgium

Front cover: Edgar Degas *A Group of Dancers*, c.1898,
National Gallery of Scotland, Edinburgh

Back cover and biographies: Giuseppe De Nittis (date,
photographer and location unknown); Federico Zandomeneghi,
c.1900 (photographer unknown), Durand-Ruel Archive, Paris;
Giovanni Boldini, 1897 (photographer unknown), Private
Collection; Medardo Rosso (date, photographer and location
unknown); Degas in his studio by Albert Bartholomé, c.1898,
Bibliothèque nationale de France, Paris

Frontispiece: Edgar Degas *Self-portrait with Floppy Hat*, 1857
Sterling and Francine Clark Art Institute,
Williamstown, Massachusetts

CONTENTS

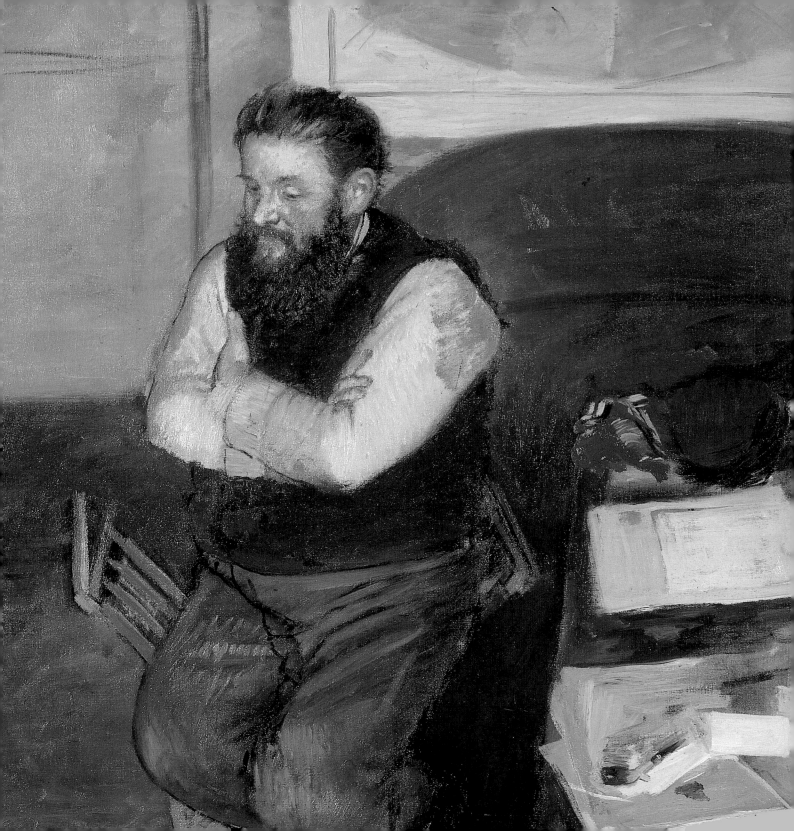

FOREWORD

In 1932 the National Gallery of Scotland made one of its most brilliant acquisitions with its purchase from Alex Reid and Lefevre Ltd of Degas's great portrait of Diego Martelli for the princely sum of £3,000. As the vendors noted to the Gallery's Director, Stanley Cursiter, 'There is no doubt whatever that it is a great bargain!' This portrait of the Florentine writer, art critic and great friend of Degas forms the centrepiece of our exhibition which examines the ties, personal as well as artistic, between Degas and a number of Italian artists who settled in Paris and entered his circle of influence. It provides fascinating new insights into the great French master who was himself part-Italian, spoke the language fluently, and visited Italy on a number of occasions, most notably on a prolonged stay from 1856 to 1859. The show has been devised and curated by Ann Dumas, working with a team of international scholars. We are most grateful to her for her efforts on our behalf and to our friends at Ferrara Arte who brought the show together and were kind enough to agree to Edinburgh being the second venue. In particular we thank Dr Andrea Buzzoni, Director, and his highly efficient colleagues, especially Tiziana Giuberti, Registrar, and Maria Luisa Pacelli, Curator. In Edinburgh much valuable work has been undertaken by Dr Frances Fowle, Leverhulme Research Fellow, Agnes Valencak-Kruger, Exhibitions Registrar and Sheila Scott, Personal Assistant to Michael Clarke. We are greatly indebted to the generosity of the lenders to the show and to our sponsors Louis Vuitton and Bank of Scotland. We have also received valuable support from the Stanley Thomas Johnson Foundation. Without their interest and support, it would not have been possible to stage this, the second of our exhibitions in the recently restored Royal Scottish Academy building.

SIR TIMOTHY CLIFFORD
Director-General, National Galleries of Scotland

MICHAEL CLARKE
Director, National Gallery of Scotland

Edgar Degas, *Diego Martelli*, 1879 (detail)
National Gallery of Scotland, Edinburgh

LOUIS VUITTON

Louis Vuitton is proud to support the National Galleries of Scotland as they present *Degas and the Italians in Paris* at the beautifully restored Royal Scottish Academy building. The National Galleries of Scotland are renowned for their unique cultural heritage and modernity – a spirit that mirrors the essence of Louis Vuitton.

Established in 1854, Louis Vuitton's rich history has always been closely intertwined with artists. Louis Vuitton, the company's founder, and his son, Georges, were friends of the photographer Nadar, who introduced them to a number of the then nearly unknown artists, including Monet, Renoir, Pissarro, Sisley, Cézanne and Degas. The father and son were among the first to see *Impression: Sunrise*, the Monet painting that inspired the name of the celebrated art movement henceforth known as Impressionism.

Louis Vuitton's collaboration with artists is a long-standing tradition for the French luxury house. Examples include the silk scarves designed by Cesar, James Rosenquist, Sol Le Witt, Jean Pierre Raynaud and Sandro Chia. In 2001, New York underground artist, Steven Sprouse, designed the highly successful 'Graffiti' collection of Monogram bags for Louis Vuitton. This initiative was followed by the collaboration with young English artist, Julie Verhoven, whose work inspired a collection of fairytale patchwork bags.

More recently, for the Spring 2003 collection, Louis Vuitton asked the Japanese *manga* artist, Takashi Murakami, to give a new dimension to Louis Vuitton's Monogram canvas. These works of art – *Eye Love Monogram*, *Cherry Blossom* and *Multicolour Monogram* have become cult objects around the world.

Support of the National Galleries of Scotland expresses the importance Louis Vuitton places in Edinburgh following the success of its first store opened in March 2003. Celebrating its 150th anniversary in 2004, Louis Vuitton pays homage to its roots founded during the heyday of Impressionism and is proud to be associated with *Degas and the Italians in Paris*.

XAVIER DE ROYERE
Managing Director, Louis Vuitton UK

✳ BANK OF SCOTLAND

It gives all of us at Bank of Scotland great pleasure to be sponsoring *Degas and the Italians in Paris*, the first winter exhibition in the newly re-opened Royal Scottish Academy building. I am delighted the Bank, as one of the largest commercial supporters of the arts in Scotland, is involved in bringing a major international exhibition by one of the world's most popular artists to Scotland, enabling visitors to view Degas's work in a new and revealing context.

Our support for this project is part of our year–round commitment to the development and promotion of the arts in Scotland. As part of this commitment we endeavour to increase access to the arts, and work closely with partner organisations to develop initiatives targeting wider audiences and increasing community involvement. We are, therefore, particularly pleased to be working with the Education Department of the National Galleries of Scotland to provide an access initiative to complement the exhibition *Degas and the Italians in Paris*.

Bank of Scotland is proud of the strong partnership we have built with the National Galleries of Scotland. Our sponsorship of this exhibition, in addition to our support for the Playfair Project, is testament to the National Galleries' achievements and dedication.

We are delighted to maintain our commitment to supporting the work of the National Galleries of Scotland and proud to be a partner in this wonderful, world-class exhibition.

DENNIS STEVENSON
The Lord Stevenson of Coddenham CBE
Chairman, HBOS plc

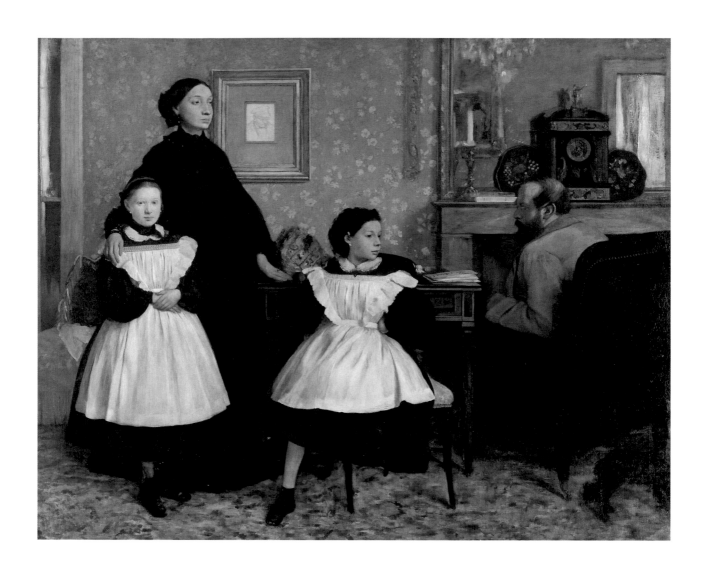

[fig.1] Edgar Degas, *The Bellelli Family*, 1858–67
Musée d'Orsay, Paris

DEGAS AND THE ITALIANS IN PARIS

ANN DUMAS

Italian art of the nineteenth century has, until quite recently, remained uncharted territory outside Italy, and has long been overshadowed by French art of the period. Some important Italian painters, however, worked or indeed settled in Paris, forming a loose circle around Edgar Degas, who himself was partly of Italian parentage and had close links to his family in Italy. *Degas and the Italians in Paris* looks both at Degas himself and at the work of four Italian artists – Federico Zandomeneghi, Giuseppe De Nittis, Giovanni Boldini and Medardo Rosso, who were associated with him. Although highly individual artists whose work differs markedly, these four Italians shared a common Parisian experience and a common link with Edgar Degas, who inspired each of them in their individual quests to capture modern life.

Degas was, without question, one of the most innovative and original artists of the nineteenth century. His exceptional awareness enabled him to capture the essence of Parisian life of his time – the café-concert, the racecourse or backstage life at the Opéra – with an unprecedented informality and immediacy. A restless and insatiable technical innovator, Degas brought a new expressive force and richness of colour to the medium of pastel. He extended the boundaries of etching, lithography, monotype and photography, and introduced new subjects and materials to the traditionally less tractable medium of sculpture.

Degas had no direct pupils. He was, however, a vital inspiration to several artists and was, on the whole, generous to those who borrowed from him. Degas was wide-ranging, not only in his artistic interests, but also in the Parisian milieus he frequented. The four Italian artists concerned here inhabited widely different Parisian social contexts yet, to different degrees, Degas had fruitful connections with them all. His Italian background undoubtedly disposed him warmly to these Italian friends and colleagues.

DEGAS IN ITALY 1856–8

Degas was Parisian to his fingertips, but his family had roots in New Orleans, on his mother's side, and, on his father's side, in Italy. This Italian background was always an essential ingredient in his character. Late in his life, his friend the poet Paul Valéry recalled him singing Neapolitan songs and arias by Cimarosa when he was in a good mood.[1] He spoke Italian, cultivated Italian friendships and even looked Italian. The oval, olive-skinned face and large, dark eyes that look out at us from his early self-portraits show a countenance more Italian than French [frontispiece].

On 17 July 1856 Degas set off from Paris for the first of three long visits to his extended family in Naples. He returned there in the summer of 1857 and again in the spring of 1860. In 1855 he had embarked on his artistic vocation, briefly enrolling as a student at Paris's principal art school, the Ecole des Beaux-Arts, but largely teaching himself by copying works in the Louvre and the Bibliothèque nationale. By 1856, however, when he was twenty-two, Degas felt it was time to enlarge his horizons. His intentions in travelling to Italy were twofold: to broaden his artistic education and to get to know his Italian relatives. Arriving in Naples, Degas felt immediately at home among his large Italian family of six aunts and uncles and many cousins, presided over by his elderly, patriarchal grandfather Hilaire, whose tapping cane announced his progress through the cavernous rooms of the

Palazzo Pignatelli di Monteleone, a vast Baroque palace in the heart of the old city. Something of the heavy opulence of the palace's interiors – with its fresco of *Heliodorus Expelled from the Temple* by the late Baroque painter Francesco Solimena gracing the entrance hall, its chandeliers, satin curtains, tapestry cushions, its marble and gilded bronze tables – can be gleaned from the inventory drawn up after Hilaire's death.

The portrait Degas painted of his eighty-seven-year-old grandfather the following summer shows his affection for this slightly stiff, austere, but kindly and cultivated man [fig.2]. The striped, light fabric of the sofa suggests that the setting is Hilaire's airy villa at San Rocco di Capodimonte overlooking the Gulf of Naples in the hills to the north of the city, where the family would escape the stifling summer heat. In this villa, Hilaire had assembled an impressive collection of paintings by contemporary Neapolitan artists, as well as a library that included the works of Voltaire, Diderot and Rousseau.

Hilaire Degas (1770–1858) had settled in Naples when he fled France at the time of the Revolution. According to a romanticised memoir written by Degas's niece, Jeanne Fèvre, Hilaire, who was wanted by the Revolutionaries because of his royalist sympathies and his engagement to one of the 'Virgins of Verdun' (the girls who presented flowers to Marie Antoinette on her way to the scaffold), fled Paris, joined Napoleon's Egyptian campaign, and ended up in Naples under the command of one of Napoleon's generals. However, in Degas's more prosaic account to the poet Paul Valéry, on 28 July 1904, it had been Hilaire's speculation on the grain market at the time of the Revolution that had forced him to flee the Terror in 1793, taking a boat from Marseilles to Naples. Arriving in the Bonapartist capital of the Kingdom of the Two Sicilies as a young and impecunious refugee, Hilaire rapidly prospered. He took employment with a wealthy Genoese merchant, Lorenzo Freppa, whose daughter Aurora he married in 1804. By 1836 he owned properties in and around Naples and had established the bank Degas, Padre e Figli with three of his sons, Edouard, Achille and Henri. The eldest son, Auguste, Degas's father, had been sent to Paris in 1825 to study commerce and eventually to run the Paris office of the family bank.

During his visits to Naples Degas made a thorough study both of the Roman frescoes from Pompeii and Herculaneum that were displayed in the Museo Borbonico (now the Museo Nazionale), making copies of details, and of the great paintings by Titian, Claude Lorrain and others that are now housed in the Capodimonte museum. He also painted delicate little landscapes of the wide, luminous plains around Naples, following a tradition of informal outdoor landscape painting in Italy established in the late eighteenth century by Pierre-Henri de Valenciennes, Thomas Jones and others. A view of the fortress of Capodimonte, which Degas could see from his grandfather's villa, inspired one of his most exquisite Italian landscapes. Another landscape, painted on a later visit to Naples, captures the ancient keep of the Castel d'Ovo

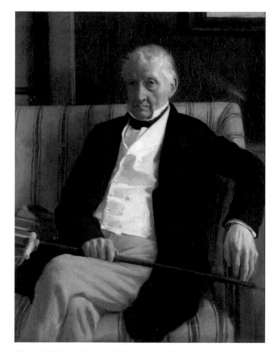

[fig.2] Edgar Degas, *Hilaire René De Gas,* 1857
Musée d'Orsay, Paris

bathed in the glow of evening or early morning [plate 42].

By October 1856 Degas was ready to make the mandatory pilgrimage to Rome, where he would stay until July the following year, returning for a second stay in October that lasted until July 1858. In the 1850s, study in Italy, and especially Rome, was considered essential for an artist's training. Degas, however, showed no interest in pursuing the traditional academic route that led to the coveted Prix de Rome and did not become a *pensionnaire* at the Villa Medici, the French Academy in Rome, although he attended evening classes in life drawing there as an informal associate. Nevertheless, his clear sense of his vocation is evident from the self-portrait [frontispiece], painted in Rome in 1857, where he presents himself as an artist, dressed in an informal, bohemian manner (with his soft hat, white shirt and orange scarf), complemented by a loose application of fluent paint that was new in his work at the time. Degas worked intensively in Rome, making copies in churches and the Vatican museums, sketching street scenes and producing numerous life drawings that he kept pinned to his studio wall until late in his life. Again, he did not neglect landscape [plates 40, 41 and 42], nor did he find Rome sufficient. He travelled throughout central Italy, immersing himself in Italian late medieval and early Renaissance art. During the summer of 1858 Degas travelled from Rome to Florence, stopping in Viterbo, Orvieto, Perugia, Assisi, Spello and Arezzo. His notebooks from these years reveal the range of art he was absorbing, from rapid sketches of Signorelli's frescoes in Orvieto Cathedral to the drawings from the cycle of frescoes attributed to Giotto in the church of San Francisco, Assisi, which touched him deeply.

It was the brilliant series of portraits Degas painted of his Italian relatives that announced his particular genius. Arriving in Florence for the first time in the summer of 1858, he stayed with his aunt Laura, her husband Gennaro Bellelli and their two small daughters in their rented apartment on the Piazza Maria Antonia (today the Piazza dell'Independenza). He had lost no time in studying the masterpieces in the Uffizi, and his notebooks are full of the copies he made of such works as Van Dyck's great equestrian portrait of *Charles V*, Bronzino's *Young Girl with a Missal* and Verrocchio's *Baptism of Christ.* A red chalk drawing after a portrait of a lady, at the time thought to be the work of Leonardo, provided the basis for one of his finest painted studies after the Old Masters. It is possible that the dignity and containment of the Renaissance portrait partly inspired the statuesque figure of Laura Bellelli in the masterpiece of Degas's early career, *The Bellelli Family* [fig.1], a group portrait of his Florentine relatives. Within the boldly structured composition, the placing of the figures reveals the emotional dislocations in this domestic scene. From Laura's letters it is clear that she was not happy with her embittered husband Gennaro, a political exile from Naples. He turns his back, while Laura, a tall, stately, black-clad figure, has the presence of a tragic, operatic heroine.

In all probability, Degas did not start work on this huge canvas until several months after his return to Paris, when he had had time to establish himself and find a studio. Yet the immense thought that went into the planning of the composition while he was still in Florence is evident from drawings in his notebooks, a study of the whole composition in pastel (Ordrupgaard, Copenhagen), and a number of studies on separate sheets of paper, notably the delightful watercolour that so perfectly captures the attitude of bored little Giulia twisting restlessly in her chair [plate 3]. For the rest of his life Degas adhered to the Old Master practice of making a series of careful preparatory studies for a composition, long after he had turned exclusively to the most modern subjects, presented with an utterly convincing impression of unpremeditated spontaneity. 'No art is less spontaneous than mine', he once declared in a now famous statement. 'What I do is the result of reflection and the study of the Old Masters.'[1]

DEGAS IN PARIS: THE PAINTER OF MODERN LIFE

Degas returned to Paris on 6 April 1859. Frequently he would go back to Naples to settle the disputes following his grandfather's will and further financial complications after the death of his uncle Achille, but from now on Paris would be his home. 'Ah Giotto! Let me see Paris and you, Paris, let me see Giotto', he confided to his notebook.[2] Establishing him-

self in a studio in the rue de Laval, he continued to work on *The Bellelli Family* for several years, in all probability exhibiting it at the Salon of 1867.

Degas continued to make portraits of his Italian relatives. One of the most sensitive is the double portrait of his sister Thérèse and her husband and cousin, the handsome Edmondo Morbilli [plate 1]. Here, Degas brilliantly captures the characters of the sitters and the nuances of their relationship, Edmondo's self-assurance and Thérèse's dependency. The calm oval of Thérèse's face, the sitters' steady gaze, and the fine silken materials of their attire imbue the figures with the magnetic allure of Bronzino's portraits. These Italian portraits display not only Degas's precocious technical mastery, but also his unusually developed sensitivity to the tensions hidden below the decorous surface of nineteenth-century familial relations.

A compelling example of this perception is Degas's portrait of his neurotic and melancholy aunt Stefania, Duchessa di Montejasi, and her two daughters Elena and Camilla [fig.3], probably painted during one of his visits to Naples in the 1870s – to look after his dying father from 1873 to 1874, in 1875 for the funeral of his uncle Achille, or in another, brief, visit in 1876. The women's black dress suggests mourning. The uncomfortable voids between the figures and the disturbing, off-centre placement of the two girls, undermine the formal arrangements of conventional portraiture. A number of years later, this type of off-centre and emotive composition is echoed in Boldini's more cheerful family portrait of the painter John Lewis Brown and his family [fig.4].

During the 1860s Degas increased his knowledge of the art of the past by studying and copying in the Louvre, and it was to Italian art that he most consistently returned. For example, in 1865 he made a copy of Sebastiano del Piombo's *Holy Family*, then attributed to Giorgione. At the same time he was producing a series of large-scale, ambitious works – *Young Spartans*, c.1860–2, *Scene of War in the Middle Ages*, c.1863–65, *Semiramis Building Babylon*, c.1860–2, *The Daughter of Jepthah*, c.1859–61 – as he tried to make his mark at the Paris Salon, the enormous annual exhibition that was the only route for artists to establish their reputation and attract buyers for their work. With *Mlle Fiocre in the Ballet 'La Source'* (Brooklyn Museum, New York), shown at the Salon in 1866,

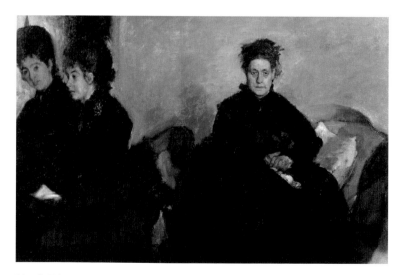

[fig.3] Edgar Degas, The Duchess of Montejasi with her Daughters, 1876
Private Collection

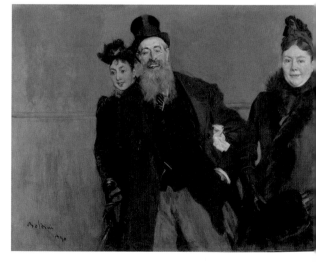

[fig.4] Giovanni Boldini, *John Lewis Brown with his Wife and Daughter*, 1890
Calouste Gulbenkian Museum, Lisbon

Degas seems to be exploring terrain between history painting and modern-life subjects. The painting is a curious hybrid of imaginary theatrical setting and a modern portrait of a famous celebrity.

The 1870s were the decade when Degas concentrated most exclusively on modern Parisian life. The two versions of *The Orchestra of the Opéra*, c.1870–1, in the Städtische Galerie, Frankfurt and the Musée d'Orsay, Paris, mark, a turning point in his work. Here he takes us unequivocally into modern Paris, into the *mondain* world of the Opéra. The foreground is occupied by what is in effect a group portrait of some of Degas's friends, the sophisticated *abonnés* (the wealthy patrons of the Opéra who were often the young dancers' 'protectors') assuming for the purposes of Degas's painting the role of orchestral performers. What makes the painting revolutionary is the fact that instead of presenting us with a straightforward view of the action on stage, reinforcing the theatrical illusion, as a more conventional artist would have done, Degas sets up a visual construct of much greater complexity, placing us in the front row of the auditorium, looking out over the darkened orchestra pit on to the magical realm of gas-lit artifice, the stage.

In the 1870s Degas was firmly aligned with the Realist movement in art pioneered by Courbet and Manet in painting and mirrored in contemporary literature by writers such as Zola and the Goncourt brothers. Like these artists and writers, Degas fulfilled Baudelaire's agenda, prescribed in *Le Peintre de la vie moderne* (1863), for the challenge of capturing contemporary life. His 'spokesman' was his friend the writer and critic Edmond Duranty, whose influential pamphlet, *La Nouvelle peinture* (1876) is generally thought to reflect many of Degas's ideas. In Duranty's view, Degas's eminent position as a Realist was a consequence primarily of his portraiture, and particularly of the way his sitters' poses and domestic settings gave them a psychological accuracy and a physical actuality reflecting the complexities of the modern world.

Degas embraced other aspects of everyday Parisian life with a directness and informality that were new. Edmond de Goncourt, who visited Degas in his studio in 1874, noted: 'Yesterday I spent my afternoon in the atelier of a strange painter named Degas. After many attempts, and thrusts in every direction, he has fallen in love with modern subjects and has set his heart on laundry girls and *danseuses* Of all the men I have seen engaged in depicting modern life, he is the one who has most successfully rendered the inner nature of that life. One wonders, however, whether he will ever produce something really complete. I doubt it. He seems to have a very restless mind.'[3]

Paris in the 1870s was a city that had undergone a recent fundamental transformation. In the opulent years of the Second Empire under Napoleon III, Baron Haussmann had razed the chaotic, medieval quarters of the city to make way for the broad boulevards lined with the tall apartment houses that make up the Paris of today. Although some of Degas's contemporaries were inspired by this new city, it is a curious fact that he himself virtually never depicted the new boulevards of Haussmann's Paris. Gustave Caillebotte recorded the broad new thoroughfares with fashionably dressed bourgeois citizens strolling along them [fig.5] and De Nittis established his reputation as the painter *par excellence* of the streets of Paris [fig.6], but *Place de la Concorde* [fig.7] is Degas's only excursion into the Parisian cityscape, even though in the last years of his life, he would often spend hours wandering the streets of Paris.

More often than not, it was the offbeat, underside of modern life that captured Degas's eye. He shows us exhausted dancers behind the scenes stretching, scratching, adjusting a shoe ribbon, waiting for their cue in the wings, flirting with the *abonnés* [plates 28, 29 and 30]. Only rarely are they portrayed performing on stage. At the racecourse, it is not the thrill of the winning horse crossing the finishing post that interests Degas, but the more abstract qualities of the jockeys' vivid silks against the grey-green hills, or the patterns of horses and riders as they tense before the start of the race and drift randomly across the landscape when it is over [plate 20].

Degas's restless mind led him to draw on a wide range of sources to achieve his vision of modernity and informality. The brilliant precision of his draughtsmanship, derived from his long study of the Old Masters and reinforced by his

veneration for the still recent work of Ingres, equipped him with the tools to pin down the most transitory and seemingly inconsequential gestures. Compositional devices also played their part. Degas frequently adopted a high viewpoint, tilting up the backgrounds of his compositions – the floorboards in a rehearsal room, for instance – drawing the figures close to the picture plane and into an immediate, and often oblique, relationship with the viewer, like someone glimpsed casually in passing. Degas is known to have owned a large collection of Japanese prints and, like many of his contemporaries, he learned from the high viewpoints, plunging perspectives and simplified designs of Hokusai, Utamaro, Sikenobou and other Japanese masters.

The focus of Degas's observation is movement and, above all, gesture. An entry in one of his notebooks tells us how he observed and admired the gestures and skills associated with particular occupations, especially professional women. Several of his drawings of dancers are annotated with detailed references to particular steps and positions. He was fascinated by the singers at those particularly Parisian establishments of the late nineteenth century, the café-concerts. One of the most celebrated of these performers, Emma

Valadon, known as Thérèsa, made her name with a *Chanson du chien* (Song of the Dog), in which, to the great hilarity of the audience, she would howl bawdy lyrics and adopt canine gestures, for example, holding up her hands like begging paws. Degas captured the posture in a famous lithograph, which he then reworked in pastel. Other pastels focus on the exaggerated pose of a singer, mouth wide open, caught in the glare of the footlights as she projects her stage personality out to an unseen audience.

In the 1880s Degas began to turn increasingly to the timeless subject of the female nude. Typically, however, he took this classical subject and recast it in a modern idiom, that of the contemporary *parisienne* bathing in her boudoir, unseen by the spectator. Degas's contribution to the eighth and last Impressionist exhibition, held in 1886, was a remarkable group of these female bathers in pastel. Their extraordinary colour combinations, strident and harmonious at the same time, inspired the perceptive critic Joris-Karl Huysmans to describe them as the 'marriage and adultery of colour'.[4] Degas had been one of the most active participants, both as an exhibitor and as an organiser, of the eight exhibitions of La Société anonyme des artistes, peintres, sculpteurs,

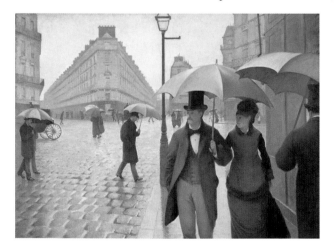

[fig.5] Gustave Caillebotte,
The Streets of Paris on a Rainy Day, 1877
The Art Institute of Chicago

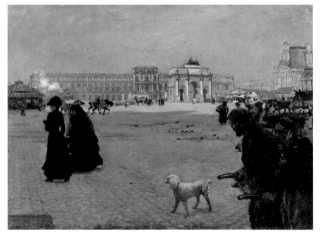

[fig.6] Giuseppe De Nittis,
La Place du Carrousel: the Ruins of the Tuileries in 1882, 1882
The Louvre, Paris

graveurs, etc., as this independent band of artists, anxious to find an exhibiting forum outside of the official Salon, called themselves. The founding members of the Société had included Cézanne, Monet, Morisot, Pissarro, Renoir, Sisley and a number of other now lesser-known names. However, after the first exhibition in 1874, the cast of artists who exhibited changed constantly, in part as a result of Degas's strong views both about invited participants and about the way works should be framed and hung. Indeed his staunch support of artists whom some of the other Impressionists regarded as too conservative led to a serious rift within the group and eventually its demise. At the seventh exhibition in 1882, for instance, Gauguin had threatened to resign in protest at Degas's support for his friends or protégés including Giuseppe De Nittis and Federico Zandomeneghi instead of 'true Impressionists'.

DEGAS'S TECHNICAL INNOVATIONS

More than any other artist of his generation Degas pushed beyond the conventional boundaries of printmaking, pastel and sculpture. Degas had often worked in pastel in the 1870s but in the 1880s he brought a new richness and visual power to what had been traditionally a rather genteel and delicate medium. A study of the glazing techniques employed by the Old Masters, particularly the Venetians, helped him formulate a method of superimposing many layers of pastel, often applying a fixative to one layer before adding the next, so that one colour could show through another. The technique enabled him to achieve exceptionally rich effects exploiting the warm and cool hues of flesh, the rich tones of auburn hair and the colours of fabrics and textiles surrounding the figure. Often the surfaces were further enlivened by vigorous patterns of cross-hatched marks. In his later works, such as his very late *Bathers*, he achieved an unprecedented vigour and freedom, allowing random squiggles of pastel to crackle over the richly layered surfaces [plates 31, 32].

Some of Degas's most daring experiments in printmaking, during the 1870s, were the result of his collaboration with Camille Pissarro and Mary Cassatt for the unrealised project of a print album to be entitled *Le Jour et la nuit* (*Day and*

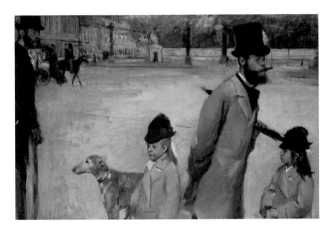

[fig.7] Edgar Degas, *Place de la Concorde*, 1875
The Hermitage Museum, St Petersburg

Night, alluding to the whites and blacks of prints). One of his most outstanding prints depicts an elegantly attired Mary Cassatt contemplating pictures, *Mary Cassatt at the Louvre: The Paintings Gallery* [plate 7]. This is a particularly striking example of Degas's *japonisme* – its high viewpoint and cropping of the figure combining to achieve an effect of casual perception, as if Mary Cassatt were being glimpsed across the room. Even the shape of the composition was determined by *hashira-e* prints designed for hanging on pillars in Japanese houses. This etching is also one of the richest in terms of print techniques: Degas combined soft-ground etching and aquatint in an unprecedented alchemy of graphic effects that he manipulated through no less than twenty states, strengthening or dissolving textures – in the marble pillar, the wooden floor, or the pleats of Mary Cassatt's skirt – from one impression to another. Degas was no less inventive in lithography. *Mlle Bécat at the Café des Ambassadeurs*, created at around the same time, demonstrates how he worked the lithographic crayon, scraping it off with a tool in the chandelier, fireworks and globe gas-lamp, to create brilliant pools of light in the darkened, nocturnal space. Degas's trademarks, familiar from other performance images of the 1870s, are obvious – the amusingly exaggerated gestures of the cabaret singer, and cropped spectators'

heads and musical instruments creating a foreground frieze.

In one of his most experimental group of works, the landscapes begun in 1890 on a trip to Burgundy in a horse and carriage with his friend, the sculptor Albert Bartholomé, and possibly continued on trips to other parts of France over the next two years, Degas combined monotype with pastel to great effect. The landscapes were shown as a group at the Galerie Durand-Ruel in 1892. In a letter Degas mentioned how the idea of creating landscapes came to him while watching the countryside slip past in a blur from the carriage window: 'I would stand at the door of the coach, and as the train went along I could see things vaguely. That gave me the idea of doing some landscapes.'[5] The painter Pierre-Georges Jeanniot, with whom he and Bartholomé stayed in Burgundy, described how Degas seemed to conjure these landscapes from memory as he smeared oil paint over the metal plate: 'We gradually saw emerging on the surface of the metal a valley, a sky, white houses, fruit trees with black branches, birches and oaks, ruts filled with water from a recent downpour, orange-coloured clouds scudding across a turbulent sky above the red-and-green earth … All these things emerged without apparent effort, as if he had the model in front of him.'[6] Often he would then pull a counterproof of the original monotype and reinforce parts of his composition with pastel in both proofs to create highly suggestive, almost abstract effects in these landscapes that he described as his 'paysages imaginaires'.

Degas's unceasing quest for new techniques, his desire always to sweep aside accepted ways of doing things and find new means that would help him get to the core of his subject, led him to new approaches to sculpture. His obsession with pose and movement led him to explore in the round the three main subjects that preoccupied him – dancers, bathers and horses. For Degas sculpture was always a private medium and no-one knows exactly when he began to make it, although scholars now mostly agree that it was probably at some point in the 1860s, with statuettes of horses. After his death in 1917, seventy-two of the numerous wax figurines found in his studio were salvaged and cast in bronze by the founder Hébrard. With the sole exception of his celebrated *The Little Dancer Aged Fourteen* [fig.8], he never exhibited his sculptures. However, the shocking verisimilitude of this piece, encased almost like an ethnographic object in her glass vitrine, amazed visitors to the sixth Impressionist exhibition in 1881. With her life-like flesh of wax, wig of human hair, real tutu and satin ballet-shoes, *The Little Dancer Aged Fourteen* overturned the conventions that dictated that sculpture was a 'high' art form that employed 'elevated' materials such as marble or bronze. Recent technical studies of Degas's sculptures have revealed the extraordinary jumble of mundane materials, ranging from bits of rag and wire to wine corks, that he incorporated into his sculp-

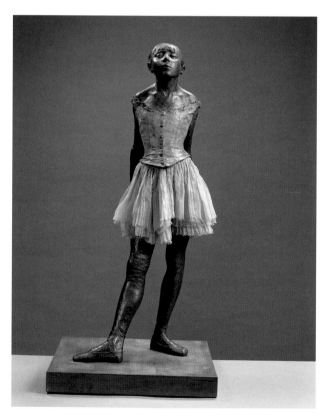

[fig.8] Edgar Degas, *The Little Dancer Aged Fourteen*, 1881
Musée d'Orsay, Paris

tures. One of the most radical of Degas's sculptures, both in conceptual terms and in the materials used, is *The Tub* [plate 51]. In this work, Degas literally takes the classical bather off her pedestal. Instead of looking up, we look down at this ordinary Parisian lying on her back washing herself with a sponge. Investigation of the original wax shows that bits of cloth and cork are embedded in the base, the tub itself is made with a piece of zinc, and the sponge is real.

DEGAS'S ITALIAN FRIENDS IN PARIS

From correspondence and snippets in memoirs and journals one can piece together a fragmentary picture of Degas's social relations with the community of Italian artists in Paris. He would, for instance, dine at Santariero, a little Italian restaurant on the Avenue MacMahon that Boldini and Zandomeneghi frequented. He was a regular guest at the Saturday evening *soirées* hosted by De Nittis and his wife Léontine and, together with Emile Zola and Edmond de Goncourt, would even occasionally join the revels of the 'polentani', the members of Circolo della Polenta, a club for expatriate and visiting Italians who would sing operatic arias, read poetry, dance, design menus and cook Italian dishes. At the Café de la Nouvelle-Athènes, the meeting place of the Impressionists in the 1870s, Degas mingled with De Nittis, Zandomeneghi, the influential critic Diego Martelli and the eccentric etcher Marcellin Desboutin, who provided another link with the Italians. In the 1850s Degas had visited Desboutin's villa L'Ombrello in the hills above Florence, where the walls were hung with Desboutin's own paintings and his immaculate copies of the Old Masters. Another Italian who formed part of the broad range of Degas's contacts in Paris was the intriguing figure of Michel Manzi, whom he would meet, along with Boldini, at another restaurant, that of Mère Morel. Manzi's varied activities encompassed printmaking, publishing and art dealing; he was also a notable caricaturist. Perhaps the most lasting consequence of Manzi's friendship with Degas, however, was the luxurious volume which he published in 1897, *Degas: vingt dessins, 1861–1896*, twenty facsimile reproductions of Degas's drawings selected by the artist to represent a whole career.

DIEGO MARTELLI

'A man of the most refined education who works for his own satisfaction rather than public admiration', in whom 'real feeling for the [Italian] primitives is illuminated by the scintillating and phosphorescent glow of our own times'. This is how the Florentine critic Diego Martelli summed up his admiration for his friend Degas in his celebrated lecture on Impressionism delivered to the Circolo Filologico of Livorno on 16 January 1880. In the 1860s in Florence he had been the ardent champion of the Macchiaioli group, who wanted to open Italy up to new ideas both in art and in politics. It is not clear precisely when Martelli met Degas, but through his friendships with De Nittis, Zandomeneghi and Desboutin he was introduced to the circle of artists at the Café de la Nouvelle-Athènes.

In the spring of 1878 Martelli made his fourth and longest trip to Paris to cover the Exposition Universelle, staying for thirteen months. During this time he mixed in French and Italian cultural circles, was a guest at De Nittis's salon and was close to Zandomeneghi. In a perceptive series of articles and lectures Martelli introduced French Impressionism to Italy. Echoing Baudelaire's words in *Le Peintre de la vie moderne*, he stressed the particularly modern quality of Impressionism, its ability to respond to 'this age of transition, both positive and sceptical, an age of immense production, nervous agitation, of crazy quests and sublime results'. In his review of the fourth Impressionist exhibition of 1879, Martelli underlined his admiration for Degas, who was, 'incontestably, one of the great French masters still alive'. He pinpointed Degas's capacity to fuse the old with the new, stressing the significance of the Italian masters in his formation: 'He came to Tuscany and found himself completely at home among his artistic ancestors, Masaccio, Botticelli, Gozzoli and Ghirlandaio. [In Florence] he saw the great masters with the eye of a Frenchman and a Parisian. Back in France, he modified his manner of capturing truth, through the example of the Old Masters.'

On a personal level, too, Martelli was fond of Degas. The warmth of feeling comes across in a letter he wrote to Signorini: 'I will remember you to Degas, of whom I see a lot

and with whom I often speak of you. He is a very agreeable man and we spend truly happy hours together. Now he has a big, cluttered studio, not at all elegant, which he will never, never manage to put in order.'

Degas's reciprocal feelings of friendship are clear from the two portraits he made of Martelli in 1879, probably just before the opening of the fourth Impressionist exhibition on 10 April [plate 6 and fig.9]. The portrait entirely exemplifies Degas's views about portraiture in the late 1870s, that the pose and setting of the sitter should reveal character. The bulky figure of Martelli, with his arms folded, squatting on his folding stool, conveys the impression of an unpretentious, intelligent man leading the transitory, makeshift life of the foreign correspondent. The telling, intimate detail of the cosy, red-lined slippers that have just been kicked off complements the journalist's muddle of papers. Degas intended to show his portrait in the upcoming exhibition, but it was probably not ready. Afterwards, Martelli's attempts, back in Florence, to obtain his portrait were in vain.

FEDERICO ZANDOMENEGHI

However, Martelli's portrait by his close friend the Venetian artist Federico Zandomeneghi did feature at the fourth Impressionist exhibition [fig.10]. Here the critic appears as a more elegant and urbane figure, and the portrait was admired for its 'fresh, even and opulent tonality'.[7] Martelli praised his friend for being the only Italian to have joined the 'Indépendants', and indeed it seems to have been Martelli's enthusiastic reports of the first Impressionist exhibition that had encouraged Zandomeneghi to leave Italy in 1874 for the French capital, where he would spend the rest of his life. It was probably through Martelli that Zandomeneghi met Degas, who invited him to exhibit in the fourth, fifth, sixth and eighth Impressionist exhibitions in 1879, 1880, 1881 and 1886, incurring the disapproval of some members of the group. Degas may well have also helped Zandomeneghi secure his three exhibitions at the prestigious Galerie Durand-Ruel in 1893, 1898 and 1903.

Zandomeneghi responded to the programme for modern art outlined in Martelli's writings and took a lead from Degas's work. Apart from his spectacular *La Place d'Anvers, Paris* or *At the Café* [plate 16], which can be compared to Degas's *In a Café (The Absinthe Drinker)*, his principal subjects were attractive young women sitting in gardens or in boudoirs at their toilette. His pastels of the female nude, a subject he pursued after seeing Degas's nudes in the last

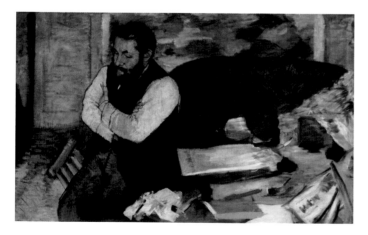

[fig.9] Edgar Degas, *Portrait of Diego Martelli*, 1879
National Museum of Fine Arts, Buenos Aires

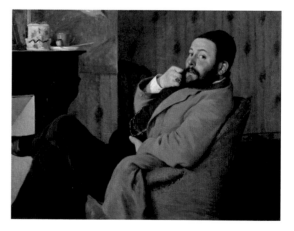

[fig.10] Federico Zandomeneghi, *Portrait of Diego Martelli*, 1879
National Gallery of Modern Art, Florence

Impressionist exhibition of 1886, demonstrate a particularly strong visual relationship with Degas, evident in the Titianesque palette of creamy white flesh tones and the warm red of the hair, achieved by building up layers of pastel, as in *Nude Woman Combing her Hair*. In a work like *The Tub* [plate 33], in which he adopts a *japoniste* high viewpoint, the debt to Degas is particularly close. Zandomeneghi sometimes even made exact copies of Degas's works, for example *Danseuses*, a copy of Degas's *Four Ballerinas*, c.1896, or *Waiting* [plate 30 and fig.11]. Spectators watching the stage from theatre boxes form part of both Degas's and Zandomeneghi's repertoire [plates 14, 15].

Ultimately, however, Zandò, as his French friends called him, was linked only tenuously with the Impressionists. Although he pursued some of their subjects and compositional arrangements, such as cropping and high viewpoints, in the end he forged a distinctive style that cannot be compared directly with any of the Impressionists. This style is particularly evident in his pastels, in which, from the mid 1880s, he acquired a new strength and individuality. Interwoven strands of strong colour suggest a closer affinity with the Italian Symbolists Giuseppe Pelizza da Volpedo or Giovanni Segantini than with the Impressionists.

Degas and Zandomeneghi seem to have been particularly close in the 1890s. In 1895, a year in which he was experimenting with photography, Degas is known to have made a portrait photograph of Zandomeneghi (now lost). In a letter to Martelli of August 1895, Zandomeneghi mentions 'four little [photographic] portraits that Degas made of me one dreadful day last winter in his studio', and, in another in November, 'a portrait of me that I had enlarged from a small negative made again by the same Degas last March in his studio …. You will think you are looking at a Velázquez'. Later that year Zandomeneghi wrote to Martelli describing a photograph made two months earlier: 'I am sending a little photograph by the tiresome Degas representing Bartholomé and me posing as rivers and the château de Dampierre in the background'. Intriguingly, Julie Manet, the daughter of Berthe Morisot and Manet's brother Eugène, noted in her diary on 29 November 1895 that Renoir had

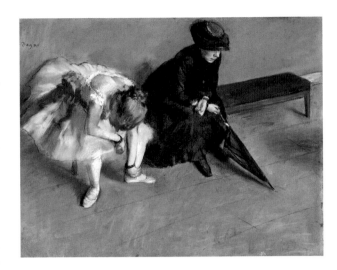

[fig.11] Edgar Degas, *Waiting*, c.1882
J. Paul Getty Museum and the Norton Simon Art Foundation, California

taken her to Degas's studio, where they found him modelling a nude in wax and working on a bust of Zandomeneghi, which has also not survived.[8]

Zandomeneghi's heartfelt grief at Degas's death was expressed in a postcard written to the critic Vittorio Pica three months before his own in December 1917. 'He was the most noble and independent artist of our era: he was a very great artist and, as long as I live, I will never forget the great friendship which bound me to him for many years.'

GIUSEPPE DE NITTIS

Of the four Italian artists represented in this exhibition Giuseppe De Nittis made by far the biggest impact in Paris. In total contrast to Zandomeneghi, who was by nature somewhat pessimistic and never made much of an income from his work, De Nittis was ambitious, buoyant and always aware of his market potential. This mercantile side of De Nittis aroused the disapproval of Martelli, and Degas occasionally shared his sentiment. Nevertheless, from the time Degas met De Nittis, probably around 1874, when he invited him to exhibit in the first Impressionist exhibition, until De Nittis's

early death in 1884 they remained close friends. Degas's genuine and deep sadness at the death of his friend is evident from the letter, dated 21 October 1884, he wrote to De Nittis's widow Léontine:

'I don't like to write and, as you will see, dear Madame, I don't know what to say. Everyday I think of him and of you and your poor Jacques. In what depths of grief you must be living! And how can one bear something like this! Close to my bedroom here there is an engraving after a painting by my poor friend, the painting *How Cold It Is!* [fig.12] and everyday I stand for a long time in front of it. The two young woman to the right, how like they are! And I remember the time when he painted it, and the studio in the Avenue de l'Impératrice and of all the fun we had. Everyday, I look at it for a long time and all my thoughts and memories are good and affectionate. He was happy and understood in the world. But it didn't last long. I need to talk to you about this. I have no taste for writing.'

Degas was a regular guest at De Nittis's Saturday *soirées*, so vividly evoked by Edmond de Goncourt: 'There [De Nittis] is again in the dining-room stirring a dish of macaroni or a fish soup … *Everything is happy* in that house. Then you

go into the studio, your eyes are amused by the Japanese prints on the walls, and with a cigarette in the mouth, your soul is moved by some beautiful music of the artist, some sonata by Beethoven.'[9]

De Nittis had first come to Paris with a group of Italian artists for the Universal Exhibition of 1867, and settled there for good in 1872. In a narrative worthy of Zola, Goncourt recounts the arrival of De Nittis in Paris, alone, penniless and not speaking a word of French. His despair was, however, instantly dispelled when he emerged from his meagre hotel and set foot on the Boulevard des Italiens: 'There, in this coming and going of men and women, in this movement, in this life of the Parisian crowd, under the gas lights, the sudden darkness that the artist felt inside, that darkness disappeared, and he was transported, enthused by the modernity of the spectacle.'[10] Goncourt thus immediately established De Nittis, like Degas, as a painter of modern life.

In 1872 De Nittis achieved his first major success at the Salon with his *Road from Barletta to Brindisi* and several views of Vesuvius [plates 43, 44 and 45]. Two years later his *How Cold It Is!* [fig.12], an image of fashionably dressed Parisians wrapped up against the cold of a winter's day in the Bois de Boulogne, was rapturously received at the Salon and established his reputation. In 1874 Degas invited De Nittis to participate in the first Impressionist exhibition, partly, as he explained in a letter, because he hoped that the presence of artists who had achieved official recognition at the Salon would confer respectability on this fringe group. However, this was De Nittis's only appearance at the Impressionist exhibitions. Renoir, who objected to De Nittis's inclusion, probably because he looked down on him as a conservative and commercial artist, made sure that his submissions (five in all, two of which were views of Vesuvius) were hung in an obscure position high up on the wall, much to De Nittis's annoyance. De Nittis's refusal to exhibit in further Impressionist exhibitions was probably also motivated by his own desire for more official recognition.

Following on *How Cold It Is!*, De Nittis made the Parisian cityscape his principal subject. He had a close friend in Gustave Caillebotte – the two artists had developed a com-

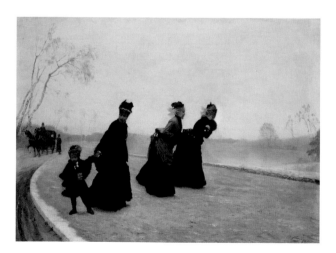

[fig.12] Giuseppe De Nittis, *How Cold It Is!*, 1874
Private Collection

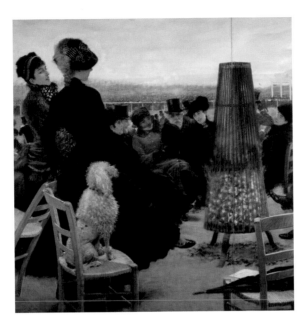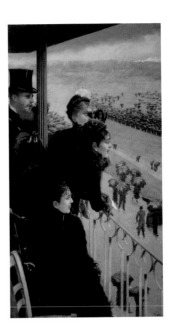

[fig.13] Giuseppe De Nittis, *At the Races, Auteuil*, 1881
National Gallery of Modern Art, Rome

mon interest in spatial depth while painting landscapes to-
gether in the environs of Naples. Caillebotte, with such cel-
ebrated images as *The Streets of Paris on a Rainy Day* [fig.5],
had established an enduring vision of Haussmann's recon-
structed Paris. De Nittis has been seen as an heir of the Ital-
ian view-painting or *veduta* tradition, but he brought to his
own city views a new and modern sense of spatial drama,
achieved by the placing of his figures against the wide Paris-
ian boulevards, avenues and squares.

Degas, as has been remarked, painted virtually no Paris-
ian street scenes. The single exception, *Place de la Concorde*
[fig.7], may, indeed, have been motivated by De Nittis's
cityscapes, in particular his *Place de la Concorde after the Rain*
of 1875 (Government Palace, Istanbul), which was exhibited
at the Salon of 1875. Later, there seems to have been a cer-
tain amount of give and take between the two artists. De
Nittis's *La Place du Carrousel: The Ruins of the Tuileries in 1882*

[fig.6], with its fashionable Parisians and dog randomly
placed in an open foreground void, seems to refer back to
Degas's *Place de la Concorde*. The high viewpoint, negative
space and tilted perspective in both works reflect the two
artists' shared enthusiasm for Japanese woodblock prints.

One of the strongest correspondences between Degas
and De Nittis lay in their approach to portraiture. Both art-
ists embraced the modern, Realist idiom articulated by the
critic Edmond Duranty in *La Nouvelle peinture*, which
stressed pose, gesture and physical setting, all of which
would convey character. In De Nittis's *Self-portrait*, for exam-
ple, the somewhat detached and intense figure gazes out
from an upholstered, opulent interior that strikingly evokes
the successful, bourgeois painter at home.

The racecourse was an aspect of modern Parisian life that
captivated De Nittis as well as Degas. Except for the occa-
sional urbane dandy leaning on his shooting stick or a sin-
gle woman gazing through her field glasses [plate 22],
Degas's interest was rarely the spectator or the public spec-
tacle. Rather it was the jockeys' gestures as they pulled on

the reins or leant forward in the saddle, and the galloping, trotting, rearing or walking of the horses, that were the subject of Degas's scrutiny. De Nittis, by contrast, captured the race and the crowds in a blur of colour, and probably his most famous work is the superb, monumental triptych of *At the Races, Auteuil* [plate 21 and fig.13], one of the highlights of the exhibition of his pastels held at Le Cercle de l'Union Artistique, Paris, in 1881.

The portrayal of women was another area of common ground between De Nittis and Degas, even if in it they also diverged considerably. The elegant *parisiennes* that became De Nittis's focus as his career progressed admirably capture the spirit of the age. At times they can acquire a coquettish, even ingratiating, manner, like that found in James Tissot's or Alfred Stevens's images of fashionable women, and of a kind that is entirely absent from Degas's portrayals. The stylish Mary Cassatt, for example, turns her back on the viewer to engage with the paintings in the Louvre [plate 7].

One of the most fascinating connections between Degas and De Nittis is to be found, surprisingly, not in the urban world at all, but in landscapes. De Nittis's landscapes are a somewhat neglected aspect of his work that reveals a visual power quite different from his more familiar views of fashionable Paris. Similarly, Degas's landscapes are a sporadic and a less familiar dimension of his work. In his remarkable series of monotype and pastel landscapes of 1890, the mysterious textures and veils of colour, in which topography blends with landscapes of the mind, suggest comparisons with De Nittis's misty, mountain views.

Degas had responded to the Neapolitan scenery in his youth, a fact that perhaps made him receptive to his friend's Italian landscapes. At a sale after De Nittis's death in 1884 Degas bought one of his Italian mountain views, and acquired another in the 1890s [plates 43, 44]. He surely had De Nittis's views of Vesuvius in mind when, in the 1890s, he produced his own monotype and pastel image of the volcano [fig.14].

Pastel is a medium in which De Nittis, like Degas, excelled. Despite the claims later made by his wife, De Nittis was probably influenced by Degas in his work in this medium, rather than the other way round. At first, he used pastel for studies and sketches, but then he began experi-

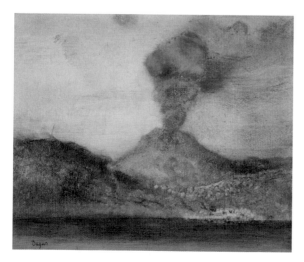

[fig.14] Edgar Degas, *Vesuvius*, 1892
Private Collection

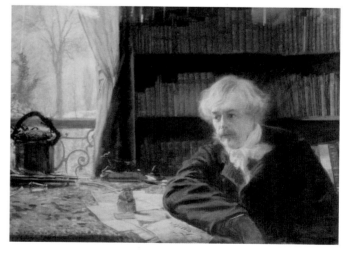

[fig.15] Giuseppe De Nittis, *Portrait of Edmond de Goncourt*, c.1880–1
Goncourt Archives, Nancy

menting with the medium on a monumental scale never attempted by Degas. The exhibition of his pastels in 1881 attracted much favourable notice. Edmond de Goncourt especially admired the range and subtlety of De Nittis's work in pastel, poetically describing his own portrait [fig.15]: 'My portrait by De Nittis, you have to see it at the hours of dusk, by the glowing embers of the fire reflected in the mirror: like that, it takes on a fantastic life that is quite extraordinary'.[11]

De Nittis also shared Degas's interest in experimental printmaking. He was friendly with the etcher Marcellin Desboutin, who may first have introduced De Nittis to Degas. At first, De Nittis used etching as a means to advertise his work, publishing his prints in the best-known reviews, *La Gazette des Beaux-Arts*, *L'Illustration nouvelle* and *L'Eau-Forte moderne*, but, around 1876, he embarked on a more experimental phase and became associated with a group of like-minded printmakers that included Desboutin, Degas, Manet, Vicomte Ludovic-Napoléon Lepic, Camille Pissarro and Mary Cassatt, who all worked with the highly innovative printer Alfred Cadart, founder of the Société des Aquafortistes in 1861.

GIOVANNI BOLDINI

Degas's friendship with Giovanni Boldini had a different character from his relationships with Martelli, Zandomeneghi and De Nittis. In their cases he acted as a significant catalyst, introducing them to the Impressionist group and to modern-life subjects. Boldini made his own way as a supremely accomplished society portrait-painter. Degas and Boldini shared, however, a profound respect for the Old Masters, and both based their art, though its character is very different, on drawing and on the capture of movement through line. For a while, when, from 1872 to 1886, Boldini was living on the Place Pigalle, close to Degas in the 9th *arrondissement*, they were neighbours.

As personalities, both were sophisticated men of the world, each noted for their acerbic wit, and, although they apparently often fell out, their friendship endured, nourished by mutual respect and by a shared enthusiasm for Old Masters, music and opera. Boldini profoundly admired

Degas as an artist and, although Degas is known to have disparaged Boldini's rather too facile virtuosity at times, he, too, recognised his friend's great ability. The dealer Ambroise Vollard recalled Degas running his hands admiringly over Boldini's monumental portrait *John Lewis Brown with his Wife and Daughter* [fig.4].

Like Degas, Boldini displayed a precocious talent in his youth and his training was thoroughly grounded in copying the Old Masters. In Florence he frequented the Caffè Michelangiolo, where he came into contact with the progressive Macchiaioli artists and Diego Martelli. Boldini was among the many Italian artists who visited the Universal Exhibition in 1867, and in 1871 he settled in Paris. It was probably around this time that he got to know Degas. He first exhibited at the Salon in 1879, and success and fame came ten years later, when he was awarded a Grand Prix at the Exposition Universelle. Honours accumulated from then on, while he exhibited successfully both at the Salon and at the prestigious Galerie Georges Petit.

Both Degas and Boldini embraced modern Parisian subjects. As we have seen, cafés, café-concerts, the world of the Opéra and of musical performers were central to Degas's modern agenda. In his Montmartre years, Boldini was an avid recorder of Parisian life, employing Degas's plunging viewpoint and dramatic asymmetry to capture fleeting impressions of sparkling café scenes [plate 18], the orchestra glimpsed from a theatre box or the panache of a bravura performer [plate 17].

In other ways, however, both Degas and Boldini turned away from the prevailing naturalist ethos. Unlike many of their contemporaries among the Impressionists, outdoor nature was not a subject of primary interest to them. Urban artifice was the world they cultivated, not only in nocturnal Paris but also in the enclosed and controlled environment of the studio. For Degas this neutral setting was a sort of laboratory in which he could manipulate a chair, a tub, a drapery and other props as he experimented with endless variations on a dancer's or a bather's pose. For Boldini, the studio was an empty stage on which the beautiful butterflies of Parisian high society could make a brief and dazzling appearance.

Although he mingled regularly with the artistic and bohemian crowd at such haunts as the Café de la Rochefoucauld, Boldini never exhibited with the Impressionists and had little respect for their work. When, in 1892, he admired Degas's exhibition of monotype landscapes at the Galerie Durand-Ruel, he specifically praised them for having nothing to do with the 'manufactured banality' of Impressionism.

Rather than the avant garde, Boldini may be bracketed with the other great society portraitists of his generation, notably Sargent, Whistler, with whom he was friends, and the Swedish painter Anders Zorn. Boldini's mature work consists almost entirely of portraits, characterised by a bravura brushwork crackling with an electric energy that perfectly conveys the rustle of shimmering materials, the spar-

kle of precious jewels and the stylish demeanour of the *beau monde*. His sources ranged from the English Grand Manner portraitists, Sir Joshua Reynolds and Thomas Gainsborough, to the Dutch seventeenth-century painter Frans Hals, whose loose, light-catching brushwork had impressed him on a trip to Holland in 1876, and the Mannerist distortions of Parmigianino (Boldini was a native of Ferrara, nearby to Parma) and the elongated figures of El Greco. Yet an equal, if not a greater, impact was made by his exposure to that great Spanish exponent of exquisite painterly surfaces, Diego Velázquez.

In 1889 Degas and Boldini travelled together to Madrid in order to study the works of the great Spanish painter in the Prado. Arriving by train at 6.30 am on 9 September, they were at the Prado as soon as it opened at 9.00 am and stayed

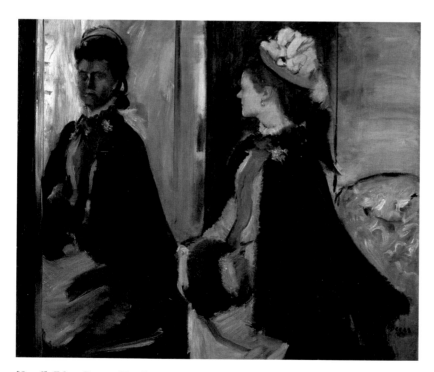

[fig.16] Edgar Degas, *Mme Jeantaud before a Mirror*, c.1875
Musée d'Orsay, Paris

[fig.17] Giuseppe De Nittis, *Portrait of the Artist's Wife*, 1882
Pinacoteca Comunale, Barletta

until midday. 'Nothing, no, nothing can give an idea of what Velázquez is like,' Degas immediately wrote to his friend Bartholomé. Boldini's 1888 *Lady in Black Looking at the Pastel of Signora Emiliana Concha de Ossa* [plate 8] suggests that he was already immersed in Velázquez the year before his visit. The multi-layered visual complexity of this work brings to mind Velázquez's *Las Meninas* (Prado, Madrid). The diminuitive figure of the artist in the background of Boldini's composition and the lady in black examining his masterpiece on the easel seem to re-live Velázquez's meditation on artist and spectator, the real and the illusory. At the same time, the lady's elegant, dark silhouette, seen from the back, inevitably recalls the elegant figure of Mary Cassatt contemplating the pictures in the Louvre in Degas's print of 1879 [plate 7], or the portrait *Mme Jeantaud before a Mirror* [fig.16].

Both Boldini and Degas in their different ways invented a new kind of modern portrait, free of conventional trappings and the formality of earlier styles. While Degas stressed pose and gesture as expressions of character and surrounded his sitters with fixtures and possessions that are counterparts to the attributes of religious and secular figures in earlier art, Boldini gradually pared away such accessories until his characters existed only in the exuberant capsules of their own personae in the empty space of the studio. From the end of the 1880s, Boldini's portraits assumed a grander scale and also more brilliant and subtle surface textures, as he, too, adopted pastel. *Signora Emiliana Concha de Ossa*, for example, is a shimmering collage of opaque and transparent whites that bring to mind De Nittis's portrait of his wife [fig.17], much admired by Edmond de Goncourt.

The 1890s, the high point of Boldini's career as a portraitist, coincided with the last phase of Degas's working life, when he largely abandoned portraiture to concentrate on an ever more searching and monumental exploration of the dancer and the nude. But Degas's undiminished enthusiasm for portraits found a new outlet in his collecting of other artists' work, an activity that occupied him most intensely during the 1890s. Outstanding portraits he acquired during these years included El Greco's *St Ildefonso* (National Gallery of Art, Washington), Ingres's portraits of M. and Mme Leblanc (Metropolitan Museum, New York) and Delacroix's *Louis-Auguste Schwiter* (National Gallery, London).

Much of the tension in both Degas's and Boldini's work comes from the dynamic between spontaneity and deliberation. In both Boldini's and Degas's work of this period, the seeming informality is the product of careful preparation. Behind the breathtaking verve of Boldini's portraits lie numerous brilliant and audacious drawings in which the positions of figures, their movements and gestures, are caught on the wing and as it were pinned to the paper. Drawing for both Boldini and Degas was a vital means of capturing movement, and Boldini, too, made rapid sketches of horses and many equally spontaneous drawings of ballerinas [plate 26]. However, it was in his fully developed portrait style that Boldini pursued the dynamic potential of line to unprecedented lengths, pushing contours beyond the forms they described and launching them on a calligraphic trajectory of their own, thus suggesting continuous movement through time in keeping with the contemporary ideas of the philosopher Henri Bergson.

Both consummate draughtsmen, Boldini and Degas explored the linear possibilities of printmaking, especially etching, which offered the physical satisfaction of incising a copper plate with a burin. Around 1878–80, when Degas was engaged in his most experimental printmaking phase, Boldini, too, began making etchings and drypoints. Degas's influence is apparent in Boldini's choices of theme, composition and technique, as in the subject and configuration of his first etching, *At the Paris Opéra*, which displays strong contrasts between very dark and brightly illuminated areas, recalling Degas's monotypes in particular.

MEDARDO ROSSO

Degas's relationship with the sculptor Medardo Rosso is the most complex and the most elusive of the four Italian artists. Evidence of any strong personal link between the two artists is tenuous and it is difficult to make a convincing case for precise mutual influence. However, if we expand our field of enquiry beyond Degas's sculpture to include the whole of

his work, a much richer understanding of his correspondences with Rosso emerges. Certainly, both reacted against the traditions of sculpture and revitalised it with new subjects and new materials. However, Rosso was exclusively a sculptor – and one of the most profoundly original talents in the history of modern sculpture – while Degas saw sculpture essentially as a private, experimental form of making art that was subsidiary to his work as a whole.

Rosso stayed briefly in Paris in 1884–5 and settled there for a longer period from 1889 to 1897. He almost certainly met Degas through the wealthy engineer and passionate art collector Henri Rouart, an old school friend of the artist, at some point in 1889, when Rouart bought a version of Rosso's *Gavroche* from the Galerie Georges Thomas. Apart from Rouart, Edmond de Goncourt was another point of contact, but there is no sense that Degas's and Rosso's social circles overlapped to any great extent. One must assume, however,

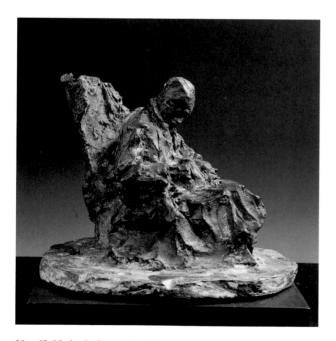

[fig.18] Medardo Rosso, *Sick Man in Hospital,* 1889
Medardo Rosso Museum, Barzio

that Degas knew Rosso fairly well, since he was a regular guest at Rouart's house and Rosso had, for a while, a working space in Rouart's metal works. Around 1886 Degas painted Rouart's daughter Hélène (National Gallery, London) surrounded by works of art from her father's collection and in 1890 Rosso made a cast of Hélène's hand as well as bust of Rouart himself. One wonders if the bust of Zandomoneghi that Degas was working on in 1895 was influenced by Rosso's portrait of their mutual friend. It was in fact in another portrait head, that of the Opéra dancer Mlle Salle, as well as in *Head Leaning on Hand* [plate 48], that Degas came closest to the sculpture of Rosso, especially to his distinctive heads *The Laughing Girl* [plate 49] and *The Sick Child,* for example.

Both Degas and Rosso interpreted modern urban life from the fleeting, blurred and fragmentary perspective of the *flâneur.* Rosso's sculpture of the celebrated, black-gloved *chanteuse* Yvette Guilbert, who was also immortalised by Toulouse-Lautrec, immediately suggests a parallel with Degas's pastels, lithographs and monotypes of café-concert singers such as *Mlle Bécat at the Café des Ambassadeurs.* While Degas seizes on the performer's theatrical gestures seen from below and caught in the glare of the footlights, Rosso achieves a comparable effect by manipulating the yellow patina (in the wax version) and flattens the singer's face.

There is nothing in Degas's sculptures to compare with Rosso's two most radical interpretations of Paris life, *Impressions of an Omnibus* and *La Place Clichy at Night* (both destroyed and known only from Rosso's photographs), but one can find correspondences with Rosso in Degas's work in other media. Degas indeed thought *Impressions of an Omnibus* was a painting when he was shown a photograph of it. Rosso's work was initially inspired by a group of passengers, including Rosso's concierge, a workman and a drunkard, whom he saw sitting on an omnibus seat. The way in which he then re-created the scene by reassembling the characters and posing them in his studio recalls the studio 'tableau' Degas set up for his painting *In a Café (The Absinthe Drinker),* in which his friends Desboutin and the actress Ellen Andrée posed as the drink-soaked drop-outs. The figures hurrying

across an empty Paris square in *La Place Clichy at Night* can be compared to that of the archetypal *flâneur*, Vicomte Lepic, in Degas's *Place de la Concorde* [fig.7]. *Woman in a Veil, Impression of a Boulevard* (Musée des Beaux-Arts, Lyons), representing the elusive and eternal passer-by on a Paris street, or the 'portrait' of the eight-year-old Alfred William Mond [plate 55], caught peering out from behind a curtain in a London drawing room, also evoke the sense of things glimpsed from the corner of an eye that is so fundamental to Degas's vision.

Rosso's sculpture known as *The Bookmaker*, which in fact captures the dandified race-goer, the quintessential *flâneur*, binoculars in hand, in the person of Eugène Martin, Hélène Rouart's husband (who, on occasion, would accompany Rouart and Degas to the races), recalls some of Degas's images of racing spectators, the woman gazing through her field glasses [plate 22] or his brother Achille leaning nonchalantly on his cane in *Achille De Gas* (Minneapolis Institute of Arts).

One most striking parallel between Rosso and Degas as sculptors is their unconventional use of materials. Most obviously, they both worked in wax, a medium traditionally reserved for experiments and maquettes, but not for the finished work of art. It must be stressed that the intentions of Rosso and Degas were very different, because Rosso intended his sculptures for public display as Degas did not. It is not clear whether Rosso knew anything of Degas's private, experimental work, and in any case Rosso was already working in wax before he left Milan for Paris, long before he met Degas. As we have seen, Degas incorporated all kinds of materials in his sculpture, and Rosso was no less experimental in mixing media. In *Sick Man in Hospital* [fig.18], for example, he left large pieces of plaster used in the original modelling wedged in the finished bronze so that the process of making became part of the finished work. He also adopted ancient techniques of patinating wax to simulate bronze. Both Degas and Rosso liked wax's malleability, because this permitted chance to play a role, as well as offering extensive possibilities for change, both physical and conceptual. Rosso, however, exploited the translucency of wax to create atmosphere and a sort of luminous nimbus around his figures, while, for Degas, it was primarily a means of modelling form. There is a similarity in the *non-finito* of the rugged surfaces both produced, Degas roughly working the wax with his fingers and thumbs and Rosso slapping it over a plaster base, and in the way in which both artists' figures seem to emerge from the inchoate mass of the wax, suggesting fluidity and flux.

Movement was an essential component of Rosso's and Degas's art, but they approached it differently. Rosso suggests movement unfolding through space in a series of fluid, episodic glimpses of reality, whereas each of Degas's sculptures defines a particular movement at a specific temporal moment. Degas always retains silhouette and the priority of the figure, while Rosso uses wax to convey formlessness and an idea of figures expanding and dissolving into the atmosphere that surrounds them. As Jane Becker has explained,[12] Rosso liked to see his sculptures exhibited with paintings, particularly Renoir's landscapes and Cézanne's outdoor bathing scenes. Although in sculpture Degas was not interested in submerging his figures in the surrounding mass, arguably in other media, and especially his later pastels, the space surrounding the figures is animated by the *matière* of the pastel in a way that moves it beyond the role of a neutral, background setting.

The merging of matter and atmosphere underlines a fundamental conceptual difference between Degas and Rosso and the aesthetic and philosophical systems to which they respectively adhered. Rosso reached for a transcendental realm in which matter is dematerialised into spirit, which aligns him with late nineteenth-century Symbolism and distinguishes him from the Realist and essentially earthbound art of Degas, springing from the opposing strain of determinist and materialist thought.

Degas's early exposure to Italy and Italian art are well known. Less familiar, until now, are his enduring friendships with Italian artists in Paris during his mature years. These relationships played an important part in the development of both his and their work.

The four Italian artists represented in this exhibition moved in very different social circles in Paris. Despite exhib-

iting in prestigious Parisian galleries, Zandomeneghi never quite moved beyond the life of a struggling bohemian. By contrast, the ambitious De Nittis achieved considerable worldly success in his short life and became a celebrated host to the Parisian cultural élite. Boldini achieved fame and fortune as the virtuoso 'court painter' to international high society, while Rosso pursued a more marginal and independent path. Degas's friendships with all of them indicate the broad range of his social contacts in Paris and belie the notion sometimes put forward that he was a recluse.

Each of these artists developed their own distinct manner, yet for each, their contact with Degas left a profound mark. The striking originality of his subjects and his techniques inspired them all. Zandomeneghi and De Nittis were particularly responsive to Degas's audacious experiments in pastel, Boldini to his draughtsmanship, while Rosso like Degas, redefined the parameters of sculpture. Each pushed beyond the established boundaries of art in pursuit of their common quest, to find a visual language capable of capturing contemporary life.

REFERENCES

1. G. Moore, 'Degas, the Painter of Modern Life', in *Magazine of Art*, vol.XIII, 1980, p.423.

2. Notebook no.22, p.5; see T. Reff, *Degas: the Artist's Mind*, New York 1976, pp.76–7.

3. E. and J. Goncourt, *Journal. Mémoires de la vie littéraire*, edited by R. Ricatte, Paris 1956, vol.I, pp.967–8.

4. J.-K. Huysmans, *L'Art moderne/Certains*, Paris 1975, pp.120–1.

5. D. Halévy, *Degas parle*, Middletown 1964, p.66.

6. E.P. Janis, *Degas Monotypes: Essay Catalogue and Checklist*, Cambridge 1968, p.xxv.

7. F.-C. Syène [Arsène Houssaye], 'Salon de 1879' in *L'Artiste*, 1 May 1879, pp.289–93.

8. J. Manet, *Journal (Diary) 1893–1899*, Paris 1979, pp.73–4.

9. E. and J. Goncourt, *Journal. Mémoires de la vie littéraire*, Monaco 1956, vol.XII, p.117, 'Saturday 11 June 1881'.

10. E. and J. Goncourt, *Journal. Mémoires de la vie littéraire*, Monaco 1956, vol.XII, p.67, 'Wednesday 25 February 1880'.

11. E. and J. Goncourt, *Journal. Mémoires de la vie littéraire*, Monaco 1956, vol.XIII, p.57, 'Saturday 13 October 1883'.

12. I would like to acknowledge Jane Becker's excellent thesis. This was enormously useful in helping me formulate my ideas about Degas and Rosso.

SUGGESTIONS FOR FURTHER READING

F. Bauman and M. Karabelnik (eds), *Degas Portraits*, London 1994

J. Sutherland Boggs, *Degas at the Races*, Washington 1998

J. Sutherland Boggs *et al*, *Degas*, New York and Ottawa 1988

J. DeVonyar and R. Kendall, *Degas and the Dance*, New York 2002

P. Dini and F. Dini, *Giovanni Boldini 1842–1931*, London 2002

G. Lista, *Medardo Rosso: Destin d'un sculpteur 1858–1928*, Paris 1994

R. Kendall, *Degas Landscapes*, London and New Haven 1993

R. Kendall, *Degas: Beyond Impressionism*, London 1996

E. Piceni, *Zandomeneghi*, Milan 1989

R. Thomson, *Degas: the Nudes*, London 1988

PORTRAITS

This depicts Degas's sister Thérèse
with her Neapolitan husband
Edmondo Morbilli whom she had
married in 1863 at the Madeleine in
Paris. A striking couple, they
inspired a strong artistic response
from Degas and illustrate his strong
family ties to Italy.

In this double portrait of Degas's
cousins Giovanna ('Nini') is aged
about seventeen and Guilia ('Julie')
fourteen or fifteen. Their mother
described them as being very unlike
each other and Degas underlines
this quality in the poses he has
chosen for them.

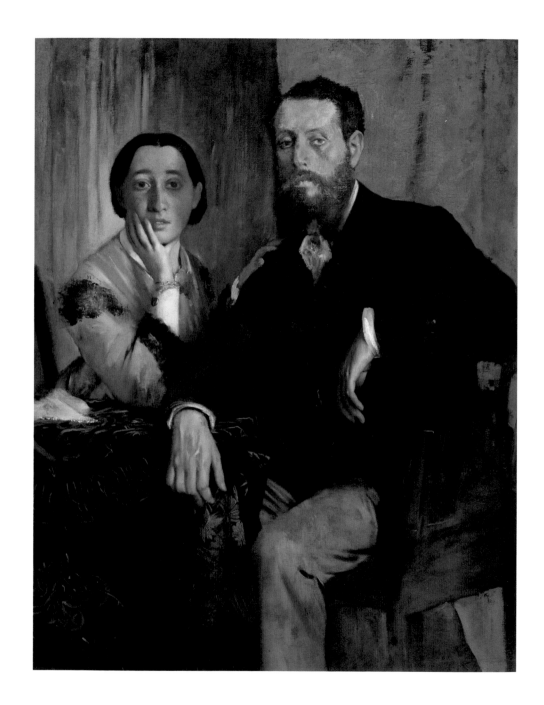

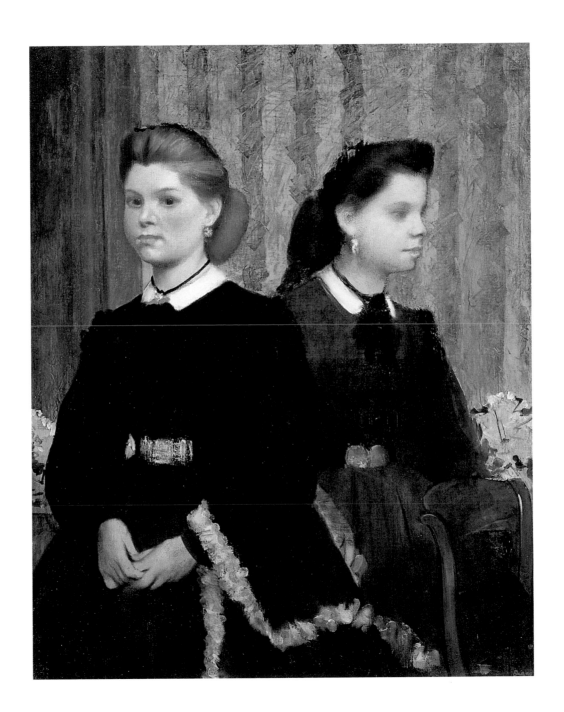

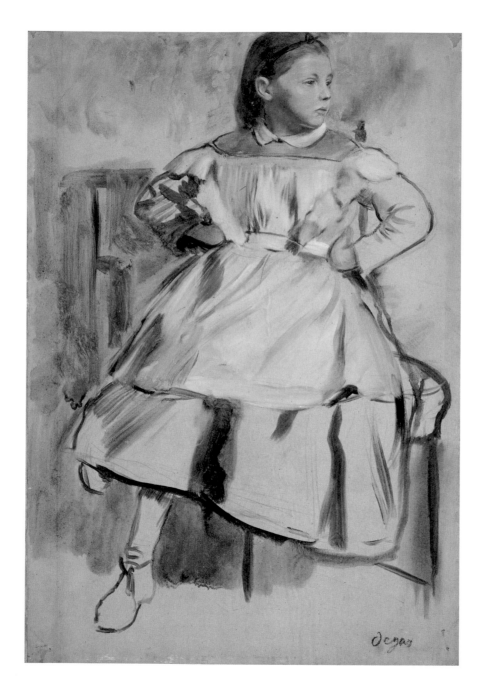

PLATE 3 | EDGAR DEGAS

*Giulia Bellelli, Study for the Bellelli Family, c.*1858–9

Dumbarton Oaks, House Collection, Washington DC

This study of Degas's cousin Giulia Bellelli was painted in Florence and used by Degas back in Paris for his great family portrait of Gennaro Bellelli, Degas's uncle, his aunt Laura and their two daughters Giovanna and Giulia. Now in the Musée d'Orsay, the picture was exhibited at the 1867 Salon.

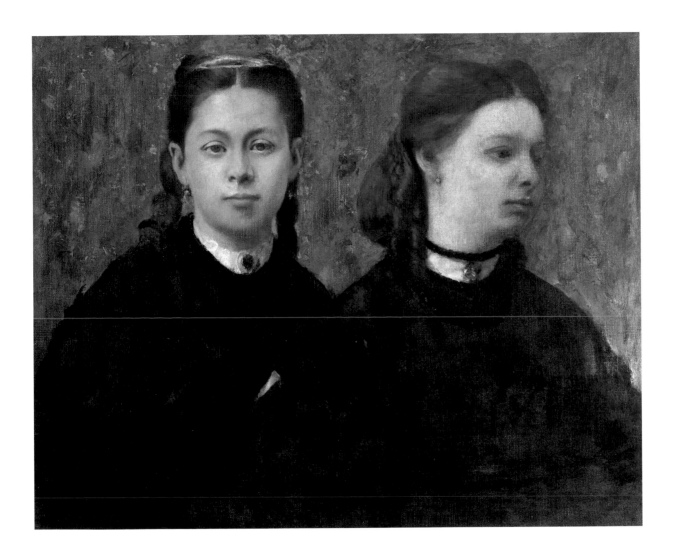

PLATE 4 | EDGAR DEGAS

*Double Portrait of the Montejasi Sisters, c.*1865–8

The Wadsworth Atheneum Museum of Art, Hartford, Connecticut,
The Ella Gallup Sumner and Mary Catlin Sumner Collection Fund

This double portrait shows Degas's Neapolitan cousins
Elena and Camilla, who were the daughters of Degas's
aunt Stefania, Duchess of Montejasi-Cicerale. Degas may
have been inspired by Théodore Chassériau's *The Two
Sisters* in the Louvre, but whereas Chassériau stressed the
emotional bond between his two sitters, Degas creates a
sense of separation by facing them in different directions.

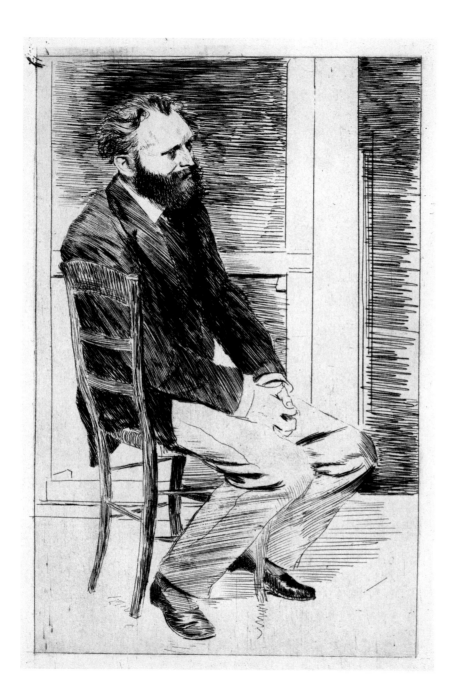

PLATE 5 | EDGAR DEGAS
Manet Seated, Turned to the Right,
*c.*1864–8
National Gallery of Canada, Ottawa

The artist Edouard Manet is seated
in front of a large canvas, its
stretchers framing his upper body.
Degas has paid particular attention
to the delicate lines around the
sitter's eyes, conveying a somewhat
melancholy, perhaps weary expres-
sion. Such detail compares with the
freer handling of the shadowed
areas.

PLATE 6 | EDGAR DEGAS
Diego Martelli, 1879
National Gallery of Scotland, Edinburgh

Diego Martelli was a Florentine
writer and art critic who in the 1860s
had been associated with the
Macchiaioli, an art movement based
in Tuscany which also had links with
Paris. This portrait of the sitter in his
Paris apartment at 52 Rue de Douai
was painted on Martelli's third visit
to the French Capital in 1878–9 and
is notable for its informality and
high viewpoint. There is another
version in Buenos Aires, a prepara-
tory drawing for which is in the
National Gallery of Scotland.

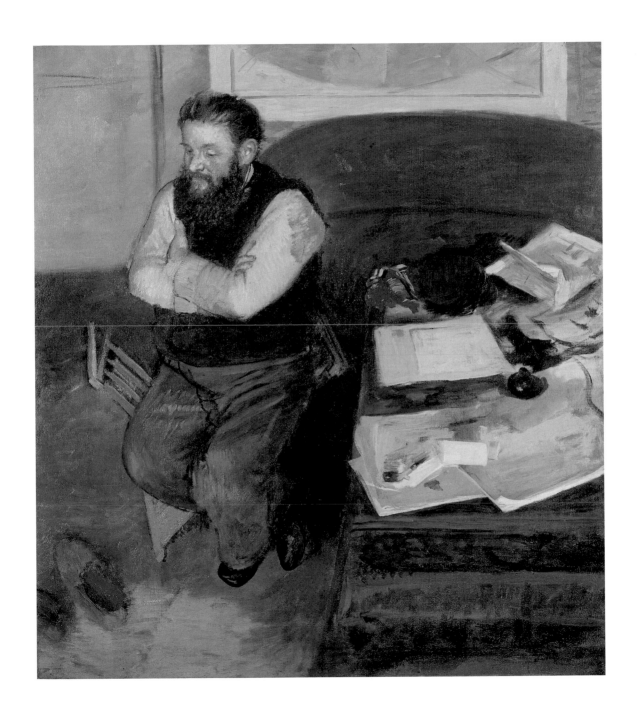

PLATE 7 | EDGAR DEGAS

Mary Cassatt at the Louvre:
The Paintings Gallery,
*c.*1879–80

Museum of Fine Arts, Boston
(Katherine E. Bullard Fund in memory of
Francis Bullard)

This etching, of which more than
twenty states are known, relates to an
earlier print of Mary Cassatt and her
sister Lydia in the Etruscan Gallery
of the Louvre. Leaning on her
umbrella, Cassatt is viewed from
behind in strong silhouette while her
sister glances up from her catalogue.
The tall, narrow format, emphasised
by the marble column in the fore-
ground, was inspired by Japanese
hashira-e prints designed for hanging
on pillars in Japanese houses.

PLATE 8 | GIOVANNI BOLDINI

Woman in Black Looking at the
Pastel of Emiliana Concha de Ossa,
*c.*1888

Museo Giovanni Boldini, Ferrara

Boldini's decision to depict the main
subject in strong silhouette, viewed
from behind, was probably directly
inspired by Degas's etching of *Mary
Cassatt at the Louvre* (opposite).
Boldini sets up a witty dialogue
between picture and viewer. Just as
the woman in black regards a woman
in white, (the portrait was known as
'The White Pastel'), Emiliano Concha
de Ossa, her head perched comically
on top of the woman's hat, stares
steadily back at us.

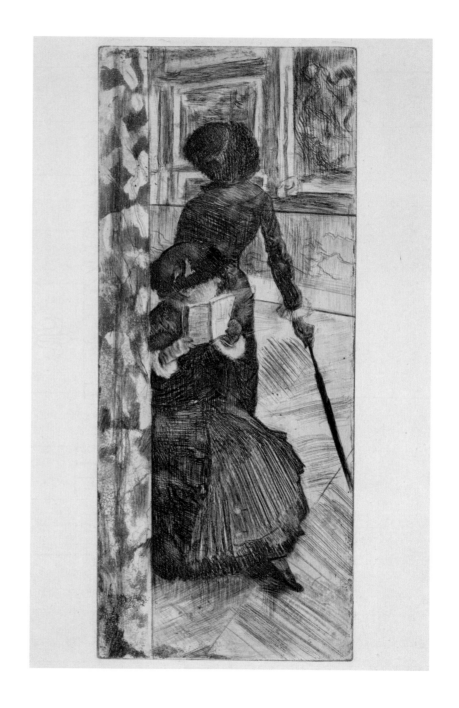

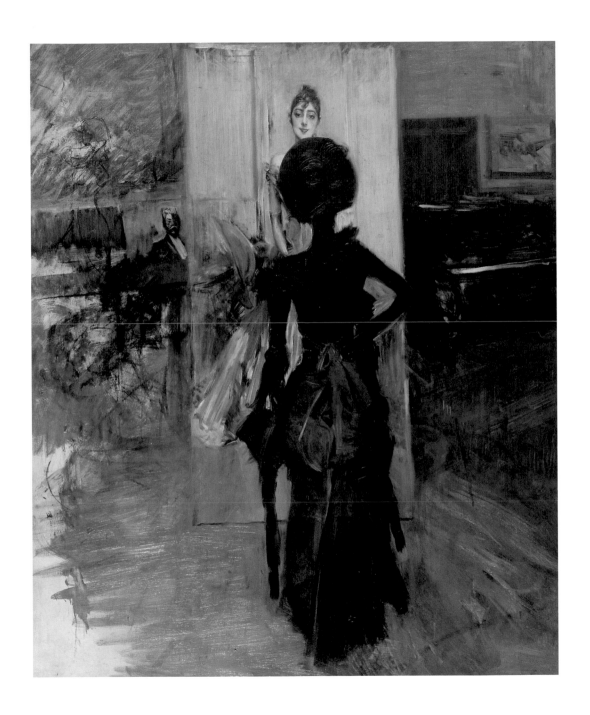

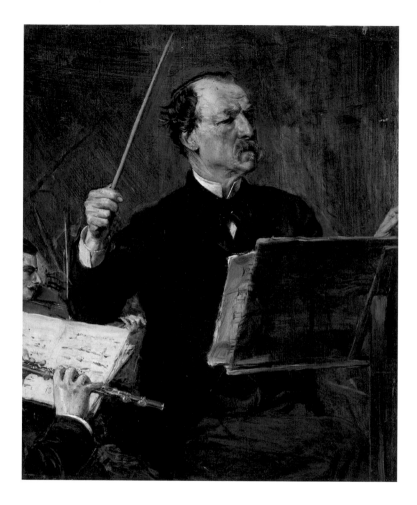

The Maestro Emanuele Muzio on the Podium, 1882

Casa di Riposo per Musicisti, Giuseppe Verdi Foundation, Milan

Boldini's close friend Emanuele Muzio was musical
director at the Théâtre Italien in Paris from 1870 to 1876.
In depicting Muzio conducting the orchestra, Boldini
was following Degas's practice of painting the sitter in
his working environment. Boldini also painted Muzio
reading the newspaper in his studio.

MUSIC, THEATRE & CAFE CONCERTS

PLATE 10 | EDGAR DEGAS

The Song Rehearsal, 1872–3

Dumbarton Oaks, House Collection,
Washington DC, Gift of Mildred and Robert
Woods Bliss

This picture dates from Degas's trip to
New Orleans in 1872–3 and depicts his
brother René his cousins Estelle and
Mathilde (or Désirée) Musson. Degas
had been accustomed since childhood
to musical evenings held in his own
home. The subject is comparable with
Boldini's *The Piano Lesson* of 1886
(Private Collection, Milan).

PLATE 11 | GIUSEPPE DE NITTIS

*In the Salon (Study for the Salon of the
Princess Mathilde)*, *c*.1883

Museo Pinacoteca Comunale, Barletta,
De Nittis Bequest

This is a study for a more finished work
in the Museo Pinacoteca Comunale,
Barletta. Princess Mathilde was the
daughter of Jérome Bonaparte and the
divorced wife of the collector, Anatoli
Demidoff. Visitors to her Salon included
a large number of artists and writers,
the most famous of which was Gustave
Flaubert. Like Degas, De Nittis was
fascinated by the effect of artificial
lighting. Here the gas lamp illuminates
the figures in the background, but the
figure in the right foreground is
plunged into shadow.

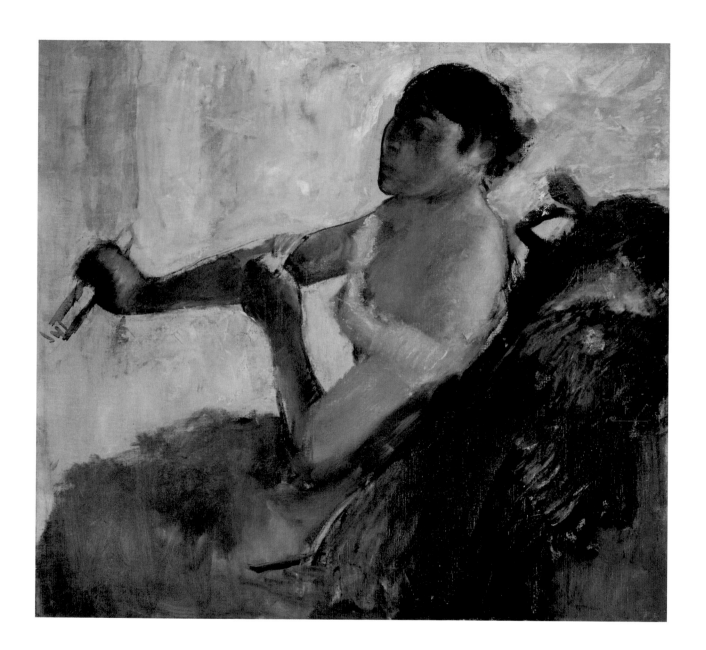

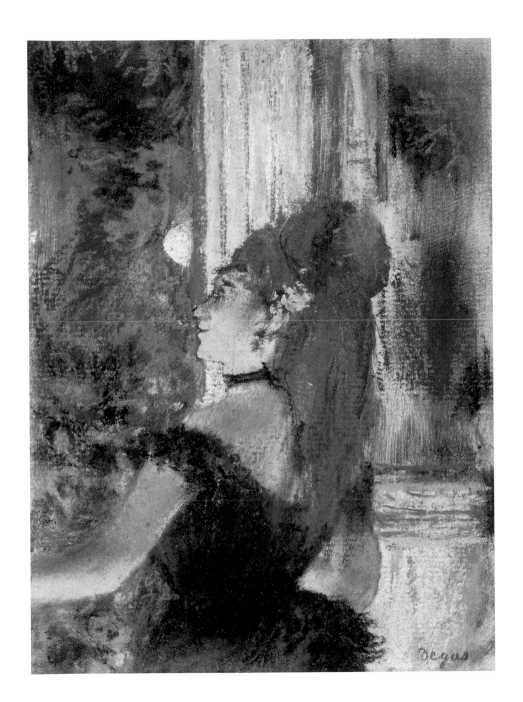

PLATE 12 | EDGAR DEGAS

*Portait of Rose Caron, c.*1892

Albright-Knox Art Gallery, Buffalo, New York, Charles Clifton, Charles W. Goodyear and Elisabeth H. Gates Funds, 1943

Rose Caron was a soprano who regularly sang at the Opéra in Paris. Degas was infatuated by her and attended at least thirty-seven productions of *Sigurd* in order to see her in the role of Brunehilde. In 1889 he wrote a sonnet to her, describing her beauty and her 'divine' voice.

PLATE 13 | EDGAR DEGAS

*The Singer, c.*1877–80

Courtesy of the Reading Public Museum, Reading, Pennsylvania

Degas uses the monotype process in this work to create strong tonal contrasts, adding touches of pastel to convey the effect of artificial light in the outdoor setting of the Café des Ambassadeurs in Paris. The glowing gas lamps flatten the features of the singer and illuminate the distinctive fluted columns of this popular café on the Champs Elysées.

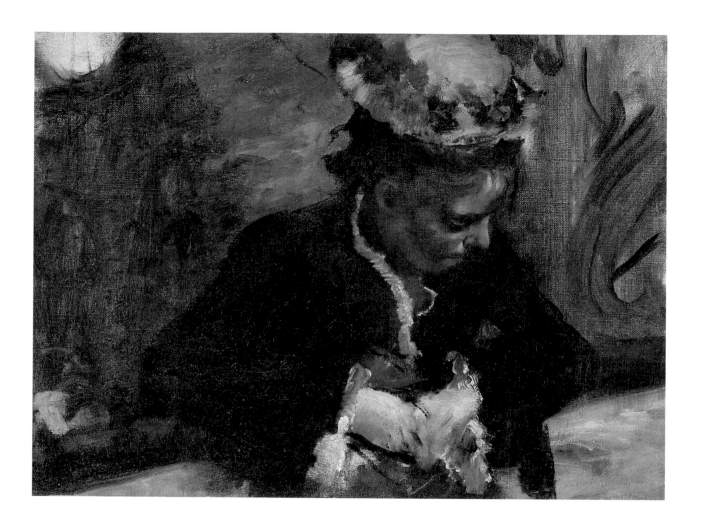

PLATE 14 | EDGAR DEGAS

At the Theatre, Woman Seated in the Balcony, c.1877–80

The Montreal Museum of Fine Arts,
Gift of Mr & Mrs Michael Hornstein

The woman in this picture is a modest working girl, seated in the balcony at the theatre. We observe her from above as she gazes down at the stage, utterly absorbed in the spectacle. Her dark eyes, pinched face and button nose recall the features of Ellen Andrée, one of Degas's favourite models.

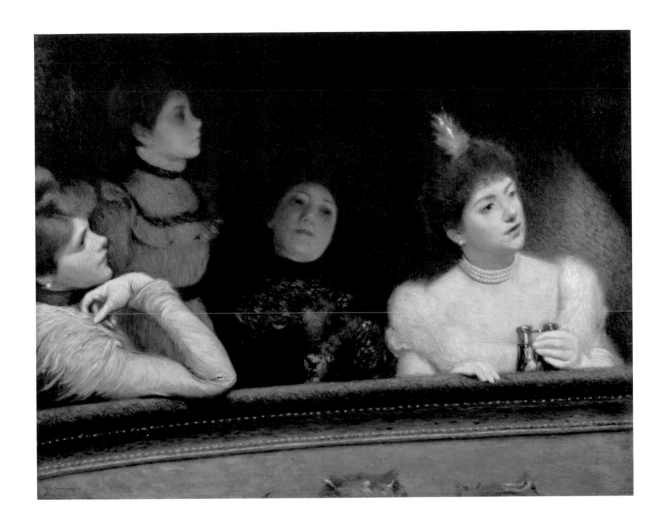

PLATE 15 | FEDERICO ZANDOMENEGHI
Theatre Box, 1885–95
Matteucci Collection, Viareggio

Renoir's *La Loge* (Courtauld Institute, London) may have provided the inspiration for this painting of a group of women at the theatre. Zandomeneghi uses light and shadow to draw attention to the young women on the right of the picture. She is equipped with binoculars with which to watch the spectacle but, in her low-cut, white evening dress and pearls, she becomes the object of our gaze.

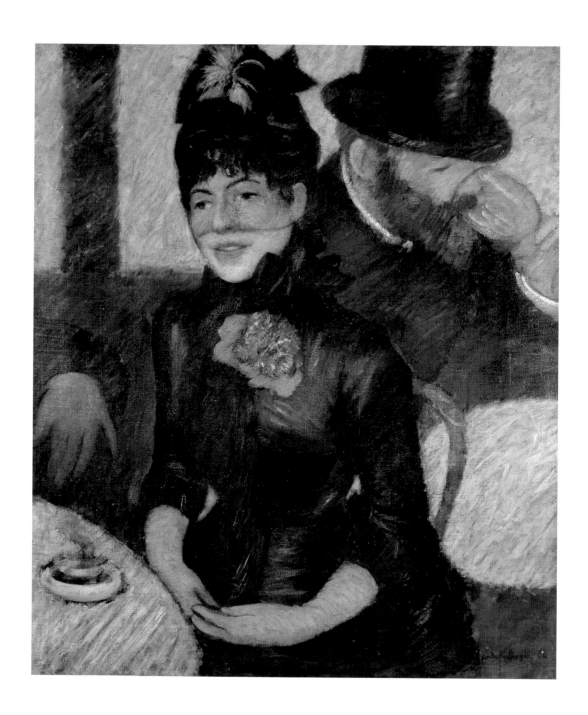

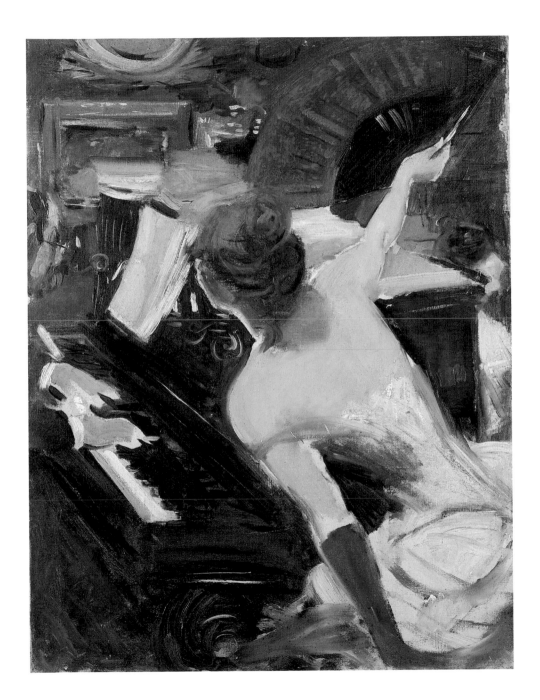

PLATE 16
FEDERICO ZANDOMENEGHI
At the Café, 1884
Museo Civico di Palazzo Te, Mantua

The subject of this picture may
have been inspired by similar café
scenes by Manet and Renoir, but
the composition, with its cropped
forms and flattened perspective,
reveals the influence of Degas. The
mirrors in the background of the
painting suggest the location is the
Café de la Nouvelle-Athènes, a
favourite meeting place for the
Impressionists.

PLATE 17 | GIOVANNI BOLDINI
The Cabaret Singer, c.1884
Private Collection

This is one of Boldini's most
daring and experimental works.
Perhaps influenced by Degas, he
views the main subject from
behind. The cabaret singer cuts a
dynamic diagonal across the
composition, as she leans into the
painting, towards the pianist,
brandishing her fan. Boldini has
used white to outline the contours
of the singer's face and arms and
the pianist's hands.

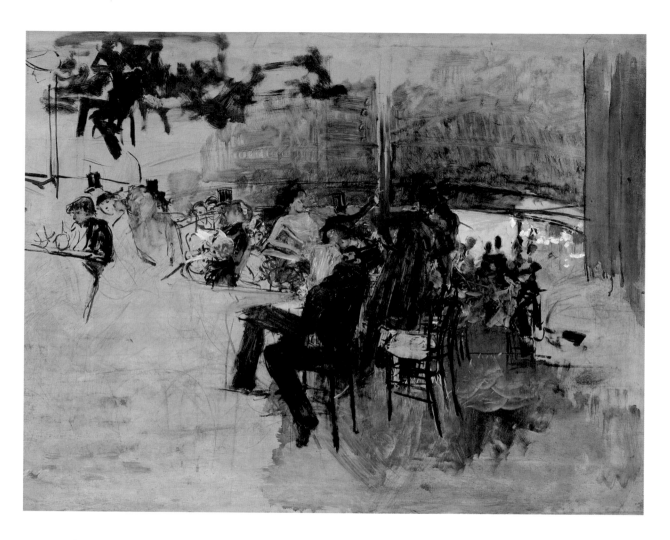

PLATE 18 | GIOVANNI BOLDINI

Study for 'The Red Café', 1887

Fine Arts Museums of San Francisco,
Gift of Whitney Warren Jr in memory of
Mrs Adolph B. Spreckels

Like the Impressionists, Boldini was committed to the representation of contemporary subjects but in contrast to them, his technique was more experimental. This is one of a series of café scenes, a study for a painting now in a private collection. It is clearly a 'work in progress', and Boldini has even sketched the scene in miniature in the top left-hand corner of the picture. The red colour evokes the hedonistic atmosphere of the café and the intense effect of the artificial lighting.

THE RACES

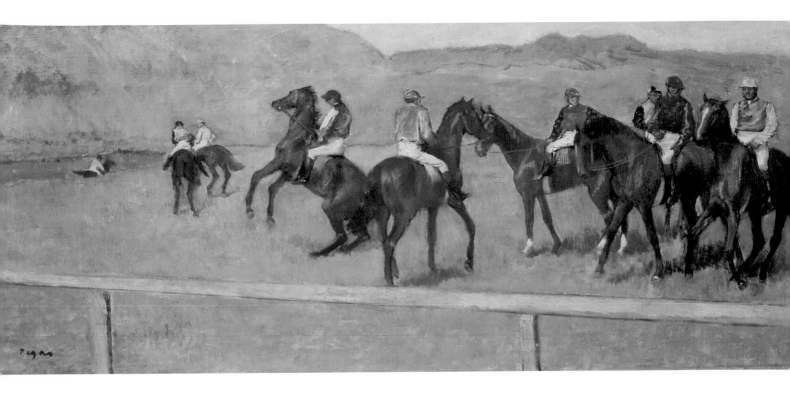

PLATE 19 | EDGAR DEGAS

Jockey (The Red Cap), c.1868–87

Museum of Art, Rhode Island School of Design, Providence, Gift of Mrs Murray S. Danforth

Towards the end of the 1860s Degas began attending the racetrack at Longchamp on the edge of Paris. Between 1868 and 1870 he produced a whole series of studies of jockeys, often viewed from behind. This painting originates from this period but was reworked by Degas with more fluid strokes at a later date.

PLATE 20 | EDGAR DEGAS

Before the Start, c.1880–90

Foundation E.G. Bührle Collection, Zurich

Just as he preferred to paint dancers waiting in the wings, rather than performing on stage, Degas was more interested in the moments before a race. Here the horses and riders are arranged in a diagonal line, waiting for the off. The eye is led towards the tiny galloping horse on the far left. The composition, with its frieze-like format, relates closely to the painting of the same title in the Virginia Museum of Fine Arts.

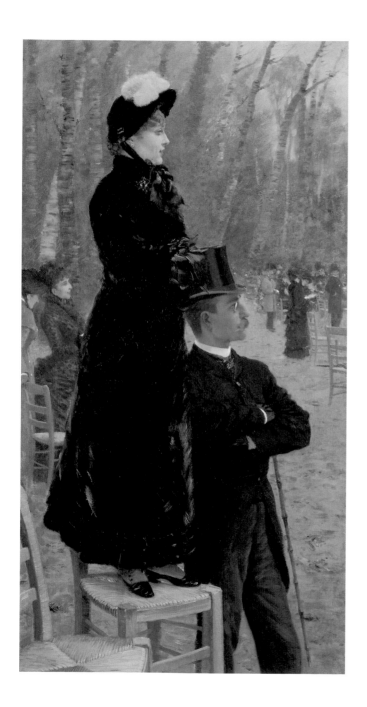

PLATE 21 | GIUSEPPE DE NITTIS

At the Races, Auteuil, 1883

Museo Pinacoteca Comunale, Barletta, De Nittis Bequest

This is a replica of the left panel of De Nittis's large triptych in pastel, *At the Races, Auteuil,* in the Galleria Nazionale d'Arte Moderna in Rome, which was exhibited in 1881 at a major exhibition of his work at the Cercle des Mirlitons in Paris. The other two panels also focus on visitors to the races: some (including a poodle) huddled round a brazier close to the racecourse; others sheltering from the rain in the grandstand (see fig.13).

PLATE 22 | EDGAR DEGAS

*Woman with Field Glasses, c.*1875–6

Galerie Neue Meister, Staatliche Kunstsammlungen, Dresden

This study of a woman with field glasses relates to two smaller sketches in the Burrell Collection, Glasgow and in a Swiss private collection. It is almost certainly a study for a figure intended to be included in a larger composition of the racecourse, but which was never carried out.

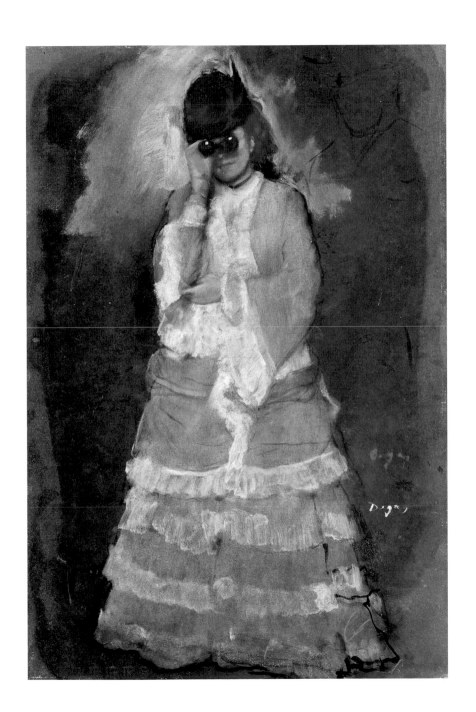

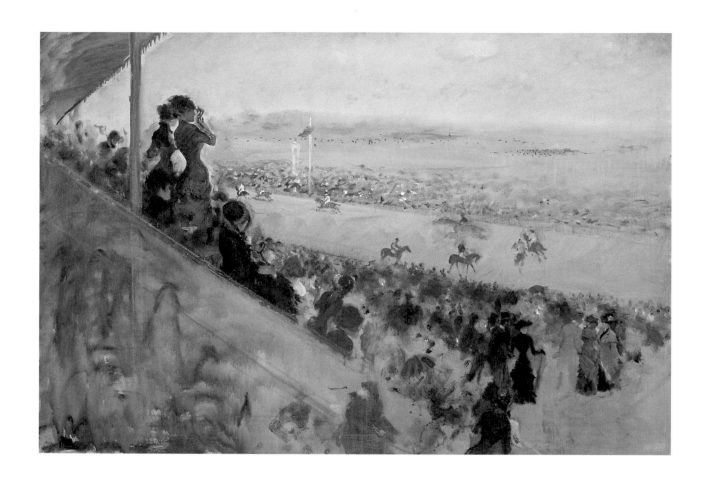

PLATE 23 | GIUSEPPE DE NITTIS

Racing at Longchamp, 1883

Museo Pinacoteca Comunale, Barletta. De Nittis Bequest

Whereas Degas preferred to focus on the racehorses,
De Nittis was more interested in the visitors to the
racecourse. Here the sketch-like handling captures the
effect of a bustling crowd, and the blurred movement
of the horses as they gallop along the track.

THE BALLET

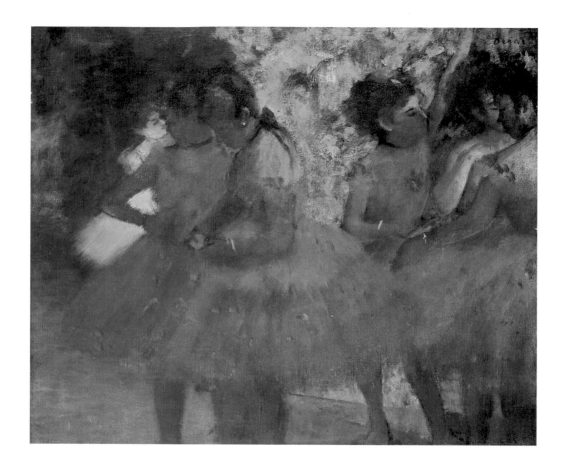

PLATE 24 | EDGAR DEGAS

*Dancers in Red Skirts, c.*1876–84

Ny Carlsberg Glyptotek, Copenhagen

As an *abonné* at the Paris Opéra, Degas was
allowed access to the ballerinas waiting in the
wings prior to going on stage. They huddle
together, the muted coral tones of their dresses
fusing together and acting as a foil to the
brightly lit figure in the left background. By
cropping the dancers' legs at ankle height Degas
brings us closer to the scene.

PLATE 25 | EDGAR DEGAS

*The Dance Examination, c.*1879

Denver Art Museum, Anonymous Gift

This painting of two young dancers preparing to be examined
by the jury of the Paris Opéra was exhibited at the Impres-
sionist Exhibition of 1880. The critics remarked upon the
dancers' awkward movements and J.-K. Huysmans was struck
by the figure in the background 'with the mug of an old
concierge', who was modelled by Degas's housekeeper. The
majority of dancers came from working class families and
were the daughters of shopgirls, laundresses and doorkeepers.

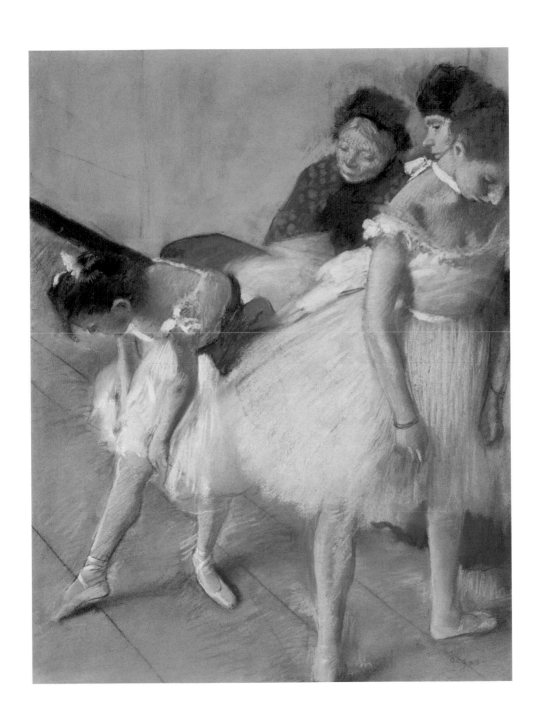

PLATE 26 | GIOVANNI BOLDINI

*Dance Step, c.*1880–90

Museo Giovanni Boldini, Ferrara

The inspiration for this drawing was Degas's pastel *The Green Dancer* of *c.*1880 in the Thyssen-Bornemisza Collection in Madrid, which was much admired in the 1880s, both in France and abroad. Boldini has drawn the dancer in mirror image and has added a second ballerina behind her.

PLATE 27 | EDGAR DEGAS

Dancer with Fan, 1894

Private Collection, London

This powerful pastel of a ballerina holding a fan is remarkable for its bold draughtsmanship and almost dissonant colours. The young dancer is in costume and appears to be waiting in the wings. However, her features are flattened by the harsh light of the footlights, suggesting that she is already on stage. Her face is upturned, framed by the blue semicircle of the fan and her out-stretched arm.

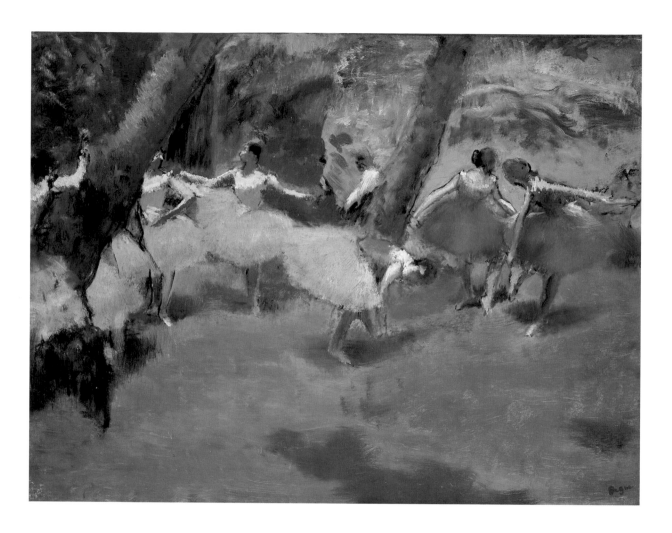

PLATE 28 | EDGAR DEGAS
Before the Performance, c.1895–1900
National Gallery of Scotland, Edinburgh

Degas was a frequent visitor to ballet performances at the Paris Opéra but he preferred to draw or paint ballet dancers waiting to go on stage, rather than record an actual performance. Here the dancers are waiting to perform at a dress rehearsal. Degas used the theme of the ballet to explore the varied poses of the human figure. The settings were often imaginary or painted from memory, the models obscure or half-forgotten dancers or hired models.

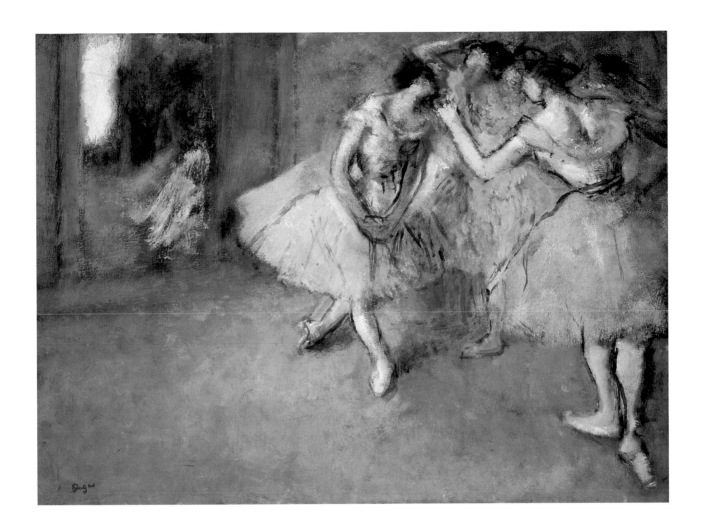

PLATE 29 | EDGAR DEGAS
A Group of Dancers, c.1898
National Gallery of Scotland, Edinburgh

Degas made his first studies of professional dancers in the 1870s and created over 1,500 paintings, pastels, prints, and drawings of this subject during his lifetime. This work of around 1898, of which there are earlier versions in pastel and oil, shows Degas treating the theme with fluency and panache. His physical involvement with the subject can be seen in the fingerprints in the paint surface where he has manipulated the paint.

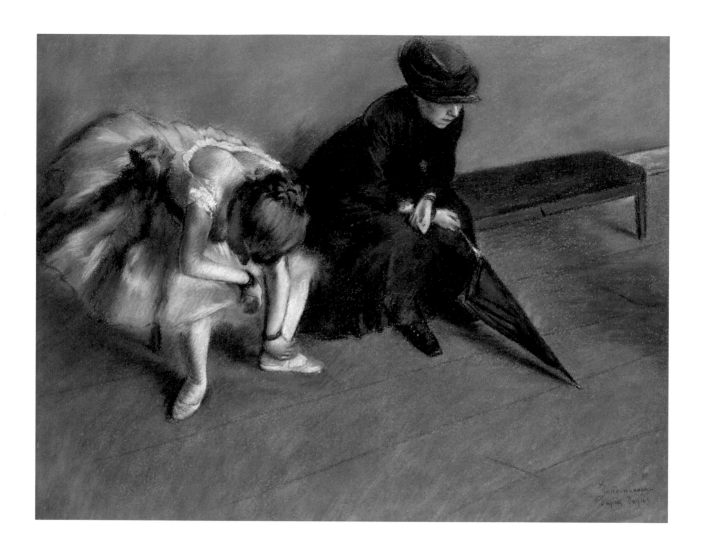

PLATE 30 | FEDERICO ZANDOMENEGHI
Waiting (copy after Degas), 1893–4
Durand-Ruel et Cie, Paris

In this copy of Degas's pastel the postures of the two figures waiting on a bench in a bare room evoke a mood of weariness and boredom. The Paris dealer Paul Durand-Ruel bought Degas's *Waiting* [fig.11] in 1892. He was extremely attached to the picture and may have commissioned Zandomeneghi to make this replica when he sold the original to the Havermeyers in 1895.

NUDES & INTERIORS

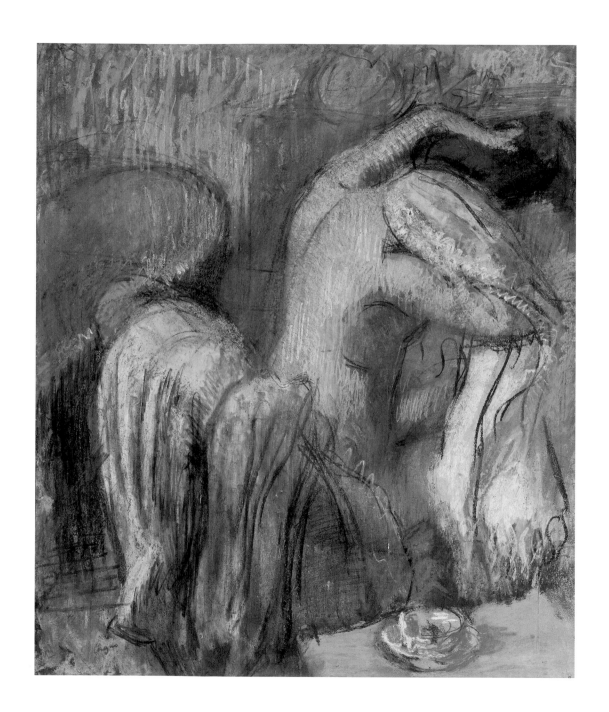

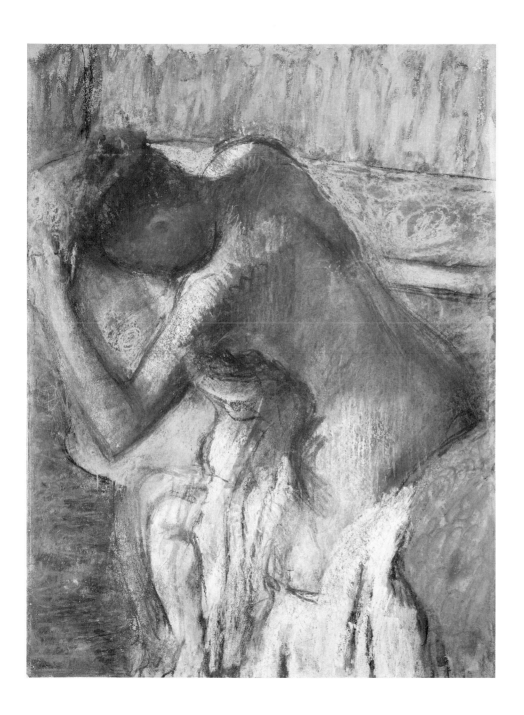

PLATE 31 | EDGAR DEGAS

Seated Bather Drying her Neck,
*c.*1900–5
Fine Arts Museums of San Francisco,
Achenbach Foundation for Graphic
Arts, Gift of Mrs John Jay Ide

The starting point for Degas's
series of solitary female nudes seen
from behind may have been
Ingres's *Valpinçon Bather* now in
the Louvre, Paris. This is one of the
most richly coloured and densely
worked of Degas's late pastels. The
figure is silhouetted against a fiery
red and orange background and
the agitated strokes of white and
grey give the impression of the
artist working at speed.

PLATE 32 | EDGAR DEGAS

*After the Bath, c.*1899–1905
Columbus Museum of Art, Ohio,
Gift of Ferdinand Howald

In this late pastel Degas is less
concerned with the bather's
personality than with the relation-
ship of the figure and her sur-
roundings. The curves of the
woman's right shoulder, buttock
and left hip are echoed by the rim
of the bath and the sinuous line of
the chairback. Degas applies the
colours with vigorous strokes,
employing blue and red cross
hatching in the shadowed areas.

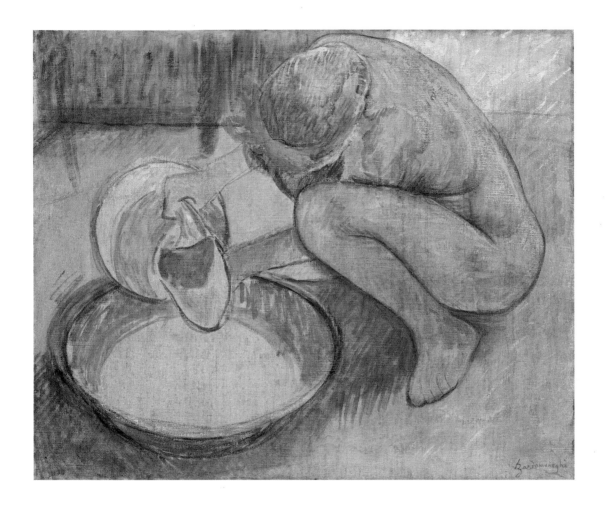

PLATE 33 | FEDERICO ZANDOMENEGHI

*The Tub, c.*1886–1900

Edmondo Sacerdoti, Milan

This work is directly influenced by Degas's pastels of women at their toilet. The high viewpoint, the figure's crouching pose and the circular form of the tub recall Degas's *The Tub* of 1886 (The Louvre, Paris) and his sculpture of the same subject [plate 51].

PLATE 34 | FEDERICO ZANDOMENEGHI

*Woman Drying Herself, c.*1886–98

Edmondo Sacerdoti, Milan

The subject and composition of this work may have been inspired by Degas's pastels of female bathers. But whereas Degas was accused of depicting women in an unflattering light, often obliging his models to adopt awkward poses, Zandomeneghi, more akin to Renoir, takes relish in the woman's curvaceous form and the sensual folds of her flesh.

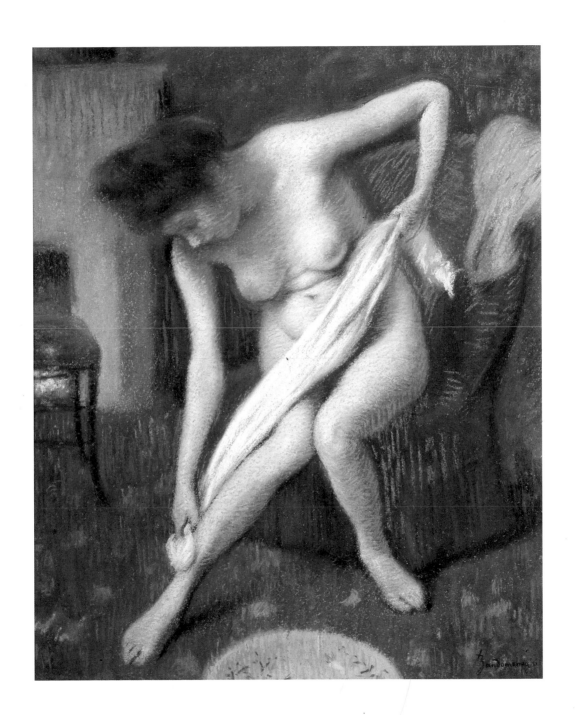

PLATE 35

FEDERICO ZANDOMENEGHI

Mother and Daughter, 1879

Matteucci Institute, Viareggio

This painting was included in the fifth Impressionist exhibition of 1880 and was admired by the critic J.-K. Huysmans. Zandomeneghi successfully combines an interest in light and atmospheric effect with an attention to detail.

PLATE 36 | EDGAR DEGAS

La Coiffure, after 1896

Nationalgalerie, Oslo

In later years Degas addressed the theme of a woman combing her hair, or having it combed or brushed by a maid or female companion. In the late nineteenth century, women typically grew their hair long and kept it up during the day. Hair brushing was a banal and tiresome routine and yet long hair was associated with sensuality and even eroticism, a duality that cannot have escaped the artist.

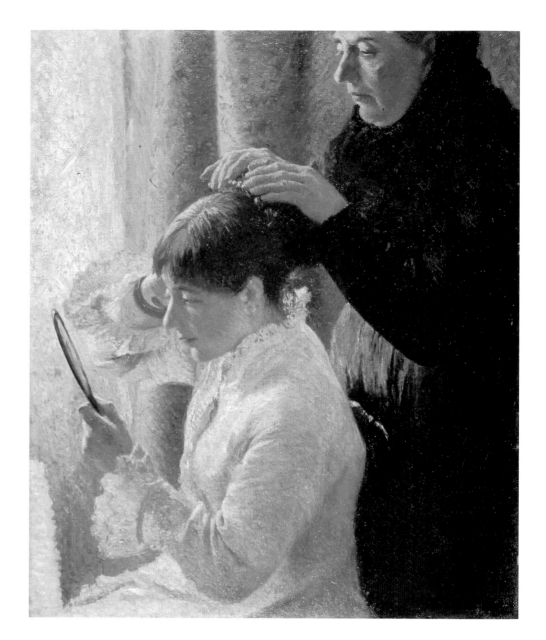

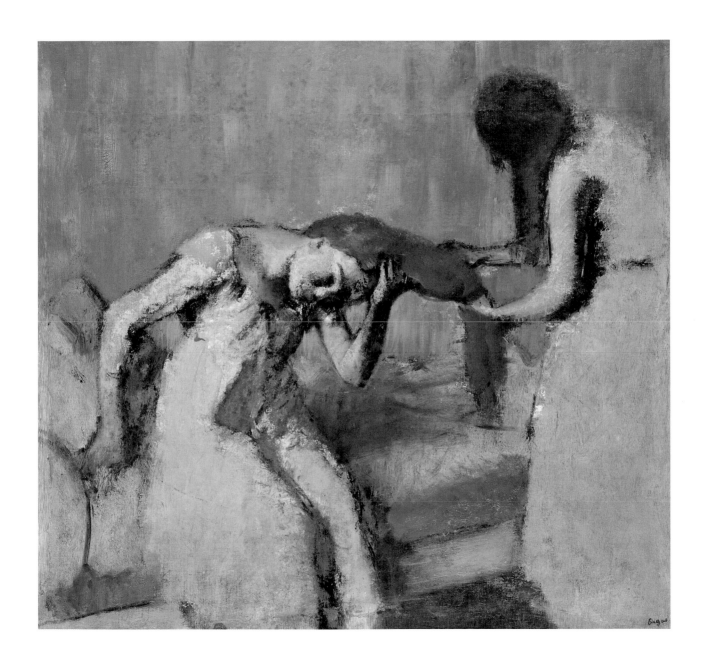

PLATE 37 | GIUSEPPE DE NITTIS
The Alcove, c.1878–80
Museo Pinacoteca Comunale, Barletta, De Nittis Bequest

This small sketch of a couple in bed recalls the humble interior scenes of Marcellin Desboutin, a close friend of both Degas and De Nittis. The poverty and drabness of their life is reflected in the muted tones of the watercolour medium. De Nittis uses the device of the alcove to crop the scene and create an unexpected, asymmetrical composition.

PLATE 38
FEDERICO ZANDOMENEGHI
*The Bedroom, c.*1886
Edmondo Sacerdoti, Milan

Like Degas, Zandomeneghi
enjoyed the versatility of
pastel as a medium. In this
picture of a corner of his
studio he uses a limited range
of colours: predominantly
blue and yellow for the alcove
and complementary reds and
greens for the rug in the
foreground. The flattened,
abstracted forms seem to
prefigure the work of Vuillard
and Bonnard in the 1890s.

PLATE 39 | FEDERICO ZANDOMENEGHI

The Awakening, 1895

Museo Civico di Palazzo Te, Mantua

This pastel confirms how close Zandomeneghi's aims were to those of Degas. This can be seen in the picture's spatial complexity, the theatrical gesture of the young woman stretching, the presence of the housemaid and the cropping of her figure half-hidden behind the wardrobe door.

LANDSCAPE

PLATE 40 │ EDGAR DEGAS

Italian Landscape seen through an Arch, 1856
Private Collection

Dating from Degas's first visit to Naples in 1856, this oil sketch depicts the
view from a window of the Palazzo Pignatelli belonging to Degas's grand-
father René-Hilaire looking towards the fortress of Capodimonte. It is one
of his earliest fully fledged landscape paintings and one of the first in a
series, using the traditioinal, neo-classical technique of oil on paper, which
he carried out during his Italian stay.

PLATE 41 | EDGAR DEGAS
View of Rome from the Tiber,
c.1858
The Langmatt Museum, Baden,
Sidney and Jenny Brown
Foundation

While in Italy 1856–9, Degas
spent much of his time in Rome
rather than with his relations in
Naples or Florence. This view
from the Tiber with St Peter's
in the distance is very much
painted in the manner advo-
cated by the French painter
Pierre-Henri de Valenciennes in
his landscape treatise of 1800. It
also recalls Camille Corot's
Italian landscapes of the 1820s,
examples of which Degas
would own in later life.

PLATE 42 | EDGAR DEGAS
Castel dell'Ovo, c.1858–9
The Langmatt Museum, Baden,
Sidney and Jenny Brown
Foundation

The group of landscape studies
Degas made in Italy 1856–9 has
received little attention until
recently. He essentially
favoured traditional French
landscape practice, albeit with
an extraordinarily atmospheric
touch. His choice of subject
matter was also relatively
straightforward. The Castel
dell'Ovo with Vesuvius beyond
was one of the most frequently
painted Neapolitan views.

PLATE 43 | GIUSEPPE DE NITTIS

*Mountainous Landscape in Italy (Vesuvius), c.*1872

Private Collection, Valdagno

Degas bought this landscape by De Nittis from Durand-Ruel in 1894. The composition, with its relatively low horizon line and picturesque disposition of elements owes much to the Italian 'veduta' tradition.

PLATE 44 | GIUSEPPE DE NITTIS

Vesuvius from Torre Annunziata, 1872

Private Collection, Valdagno

De Nittis was in Naples when Mount Vesuvius erupted in April 1872. He produced several picturesque views of the volcano for the Paris dealer Adolphe Goupil, as well as numerous *pochades* (small sketches). Degas bought this work from the sale of De Nittis's studio in 1884.

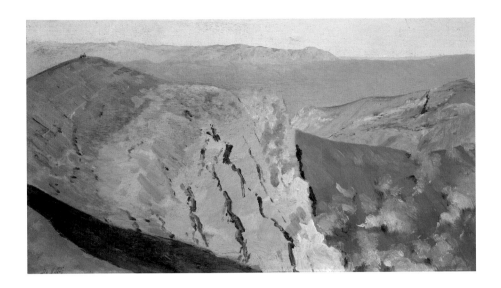

PLATE 45 | GIUSEPPE DE NITTIS

*The Crater, Vesuvius, c.*1872

Private Collection, Valdagno

This is one of a series of small sketches of Mount Vesuvius that De Nittis produced for the Paris dealer Adolphe Goupil in 1872. He gives an indication of scale by including two tiny figures, seated on the edge of the crater, at the top left of the painting.

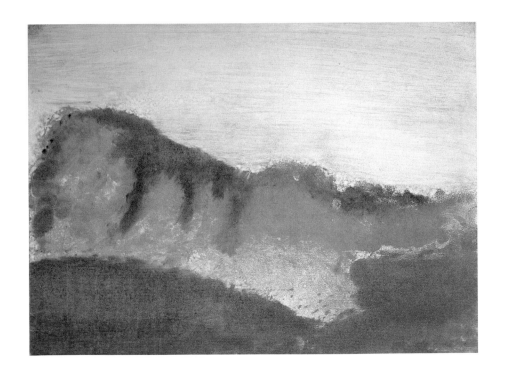

PLATE 46 | EDGAR DEGAS

*Le Cap Hornu, c.*1890

The British Museum, London

Degas's landcape monotypes were loosely inspired by memories of journeys through France and Switzerland from 1890–92. Despite the title, there is no evidence that this represents an identifiable location. The forms, suggestive of brown cliffs and green meadow, emanate from Degas's imagination.

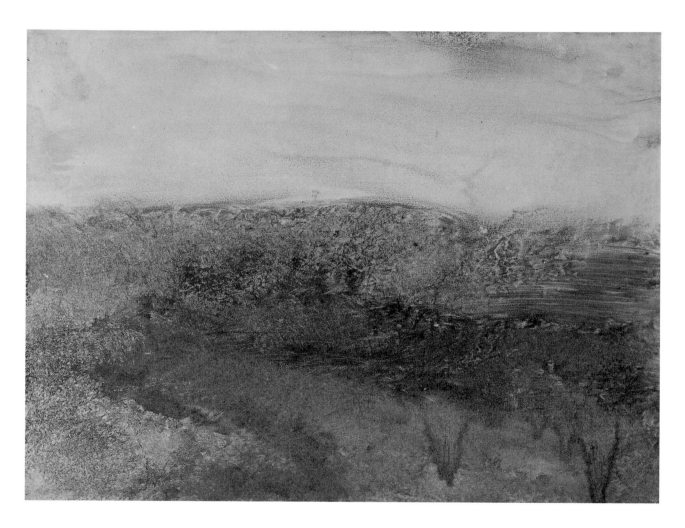

PLATE 47 | EDGAR DEGAS

*Landscape by the Sea, c.*1892

Musée d'Art et d'Histoire, Neuchâtel

Degas presented this landscape monotype to the publisher
and magazine proprietor Georges Charpentier who was an
important patron of both Renoir and Monet. Charpentier
went on to acquire further works from Degas in the late
1890s, including a second landscape.

SCULPTURE

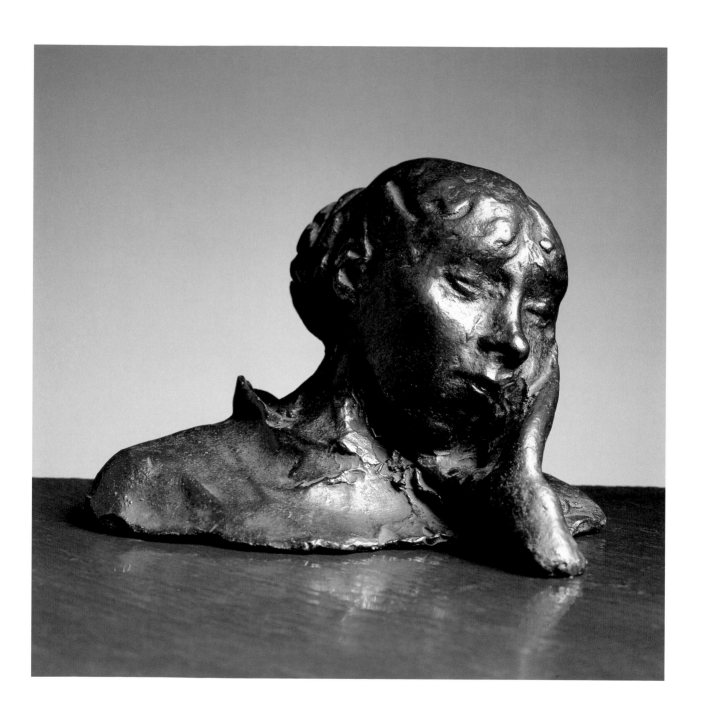

PLATE 48 | EDGAR DEGAS

Head Leaning on Hand, 1882

Musée d'Orsay, Paris, acquired through
the generosity of the artist's descendants
and the Hébrard family, 1930

The modernity of this work lies in
the artist's choice, then unprec-
edented, of dispensing with the
base, so the hand supporting the
head seems to rise out of emptiness.
This is a gentle depiction of a
woman dozing. It may depict the
wife of Albert Bartholomé, a close
friend of Degas.

PLATE 49 | MEDARDO ROSSO

The Laughing Girl, 1890

Musée Rodin, Paris

The model for this work was Bianca
Garavaglia, a singer at the café
concert. Rosso captures her de-
lighted expression as she receives
the applause of her audience. From
1893 onwards Rosso developed a
close friendship with the great
French sculptor Auguste Rodin, and
swapped this work for Rodin's
bronze *Torso*.

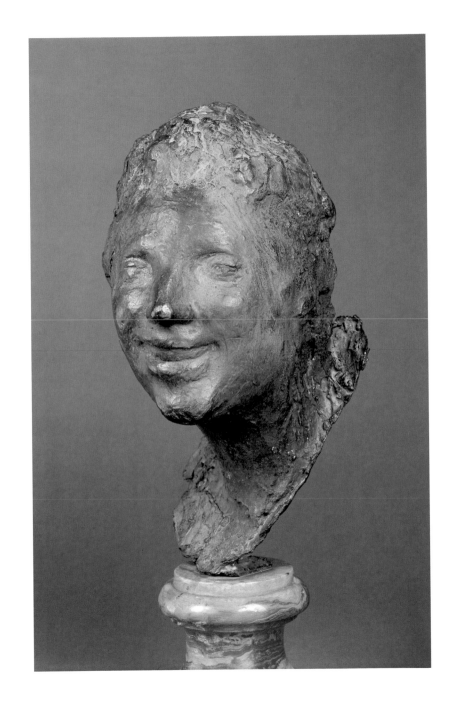

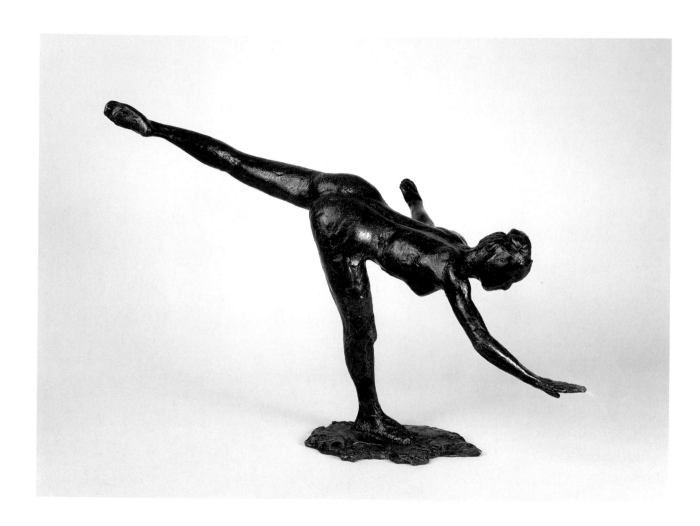

PLATE 50 | EDGAR DEGAS

Arabesque penchée (wrongly called Grand Arabesque),
c.1892–6

National Gallery of Scotland, Edinburgh

Degas greatly admired the grace and discipline of the dancers he observed at the Paris Opéra. The arabesque penchée required tremendous control, requiring the dancer to remain perfectly stable on one foot while raising the other as high as possible. Of the bronzes cast by Hébrard from 1919 to 1921 from Degas's surviving wax models, seven show dancers in different positions of the arabesque. The original wax model for this sculpture was executed between 1882 and 1895 and was cast in an edition of twenty-two.

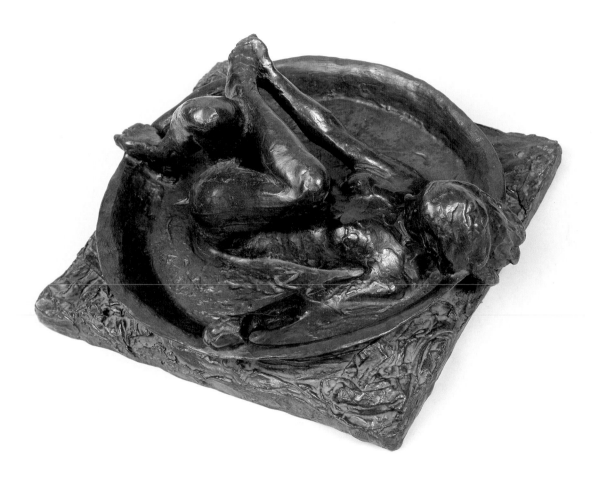

PLATE 51 | EDGAR DEGAS
*The Tub, c.*1888–9
National Gallery of Scotland, Edinburgh

The tub is one of Degas's most interesting and innovative works in sculpture and a dramatic break from the classical tradition. Part of the effect depended on the different colours and textures of the original, which was worked in various materials: the tub was sculpted in lead, the water in white plaster and the figure in red wax. Degas made a base from rags soaked in plaster and the bather held a real sponge in her hand.

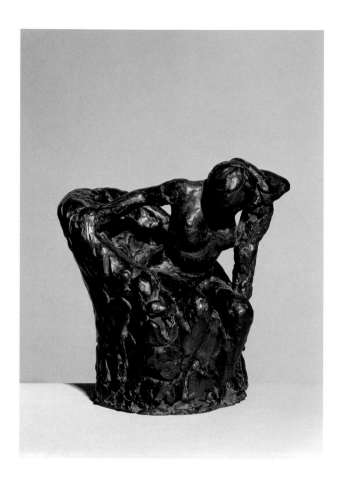

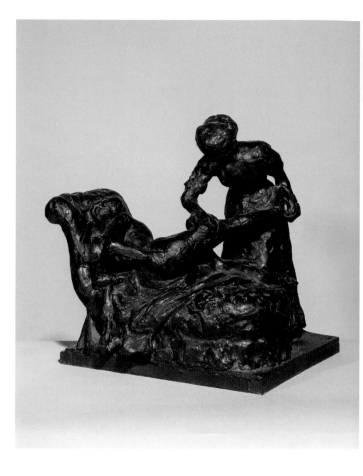

PLATE 52 | EDGAR DEGAS

*Seated Woman Drying her Neck, c.*1895–6

Musée d'Orsay, Paris, acquired through the generosity of the artist's descendants and the Hébrard family, 1930

In this work, there is a marked similarity to Rosso's *Sick Man in Hospital* [fig.18] in the blending of the figure and the armchair into one mass. In both works the marks left by the sculptors' fingers remain visible.

PLATE 53 | EDGAR DEGAS

*'La Masseuse', c.*1895

Musée d'Orsay, Paris, acquired through the generosity of the artist's descendants and the Hébrard family, 1930

La Masseuse belongs to a group of small nudes modelled by Degas. In these works, the artist studies in greater depth the movement of the human body that had been the focus of his recent pastels of dancers and nudes, with the figure of a housemaid often introduced as an element in the composition.

PLATE 54 | MEDARDO ROSSO

Conversation in the Garden, 1896

Galleria Nazionale d'Arte Moderna, Rome

Rosso was fascinated by the relationship
between a figure and its surroundings, and
by the way in which light could transform or
'dematerialise' a solid object. This is
exemplified by this work, which translates
into sculpture the Impressionist idea of
working in the open air.

PLATE 55 | MEDARDO ROSSO

Ecce Puer (Behold the Boy), 1906
Musée d'Orsay, Paris

Rosso was commissioned to
produce this sculpture by the
Mond family who were wealthy
bankers. His young subject,
Alfred William Mond, appeared
one evening from behind a
curtain and peered in at the
assembled company. The veiled
indistinct details and irregular
edges are intended to convey the
way in which the boy's face
emerges into the light and
interacts with the surrounding
atmosphere.

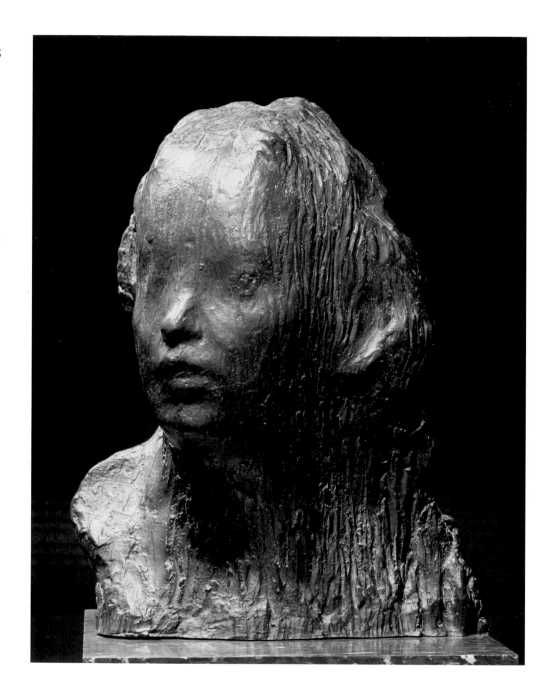

CHRONOLOGY

- **1856** Degas arrives in Naples on 17 July, having travelled from Marseilles. He stays with his Bellelli cousins at 53 Calatà Trinità Maggiore. During this period he makes numerous copies of works at the National Museum in Naples and produces a portrait of his cousin Giovanna Bellelli. On 7 October Degas leaves Naples for Civitavecchia and Rome where he stays until July 1857. During this visit he attends the Villa Medici, the home of the French Academy in Rome.

- **1857** Degas returns to Naples on 1 August and stays at his grandfather's villa at San Rocco di Capodimonte until late October. He paints two portraits of his grandfather, Hilaire Degas, then eighty-seven years old. In late October he returns to Rome and stays until July 1858. He makes copies of works in the Sistine Chapel, the Doria Pamphili Gallery and the Capitoline Gallery.

- **1858** On 24 July Degas travels from Rome to Florence, stopping in Viterbo, Orvieto, Perugia, Assisi, Spello and Arezzo. In Florence he stays with his aunt Laura Bellelli and family at her apartment, 1209 Piazza Maria Antonia. He does numerous copies of works in the Uffizi. Hilaire Degas dies in Naples on 31 August.

- **1859** Degas is working on his portrait of the Bellelli family. In March he accompanies Gustave Moreau to Siena and Pisa. He leaves Florence later that month and returns to Paris, arriving on 6 April. He stays with his father, Auguste De Gas, in his apartment at 4 rue de Mondovi.

- **1860** On 21 March Degas makes a trip to Naples and stays with his aunt 'Fanny', Marchessa di Cicerale and Duchessa di Montejasi and her two daughters, Elena and Camilla di Montejasi. He see his two sisters Thérèse and Marguerite and visits his Morbilli cousins on 22 March. He leaves Naples on 2 April for Livorno and goes to stay with the Bellelli family in Florence. He returns to Paris towards the end of the month.

- **1862** Degas meets Manet and through him is introduced to the young Impressionists at the Café Guerbois in Paris.

- **1863** Thérèse De Gas marries her first cousin Edmondo Morbilli on 16 April at the Church of La Madeleine in Paris. Degas paints their portrait soon after their marriage.

- **1867** A large contingent of Italian artists, including Boldini and De Nittis, visits the Exposition Universelle in Paris.

- **1868** De Nittis arrives in Paris on 4 June and settles at Bougival. He signs a contract with the dealer Frédéric Reitlinger.

- **1869** De Nittis marries Léontine Lucile Gruvelle on 29 April. Diego Martelli travels briefly to Paris to visit the Salon.

- **1870** Reitlinger travels to Florence and Rome and gets to know Boldini.

- **1871** De Nittis spends much of this year in Italy, returning to Paris in September. Boldini settles in Paris. On 1 November he moves into 12 avenue de Frocot with Berthe, a model. He drops Reitlinger in favour of the dealer Adolphe Goupil.

- **1872** De Nittis signs a contract with Goupil. He achieves his first major success at the Salon with his *Road from Barletta to Brindisi* and several views of Vesuvius. Boldini moves to 11 Place de Pigalle. Michel Manzi moves to Paris and befriends De Nittis. Degas travels to New Orleans, where he stays until late March 1873.

- **1873** In November Degas travels to Turin to look after his father, who has taken ill en route to Naples. He returns to Paris by 8 December.

- **1874** Auguste De Gas dies in Naples on 23 February. The first exhibition of the Société Anonyme des Artistes (the first Impressionist Exhibition) opens at 35 boulevard des Capucines on 15 April. Invited by Degas, De Nittis participates for the first and only time, contributing five works, including two studies of Vesuvius. His *How Cold It Is!* (Private Collection) is well received at the Paris Salon. De Nittis is now a great commercial success in London as well as Paris and cancels his contract with Goupil.

• **1876** The second Impressionist exhibition opens on 30 March. Degas exhibits twenty-two works. He briefly visits his brother Achille in Naples in June.

• **1877** The third Impressionist exhibition opens on 4 April. Degas contributes twenty-three works. Zandomeneghi exhibits for the first time at the Paris Salon.

• **1878** De Nittis meets Edmond de Goncourt in mid-February. Diego Martelli travels to Paris on 3 April and stays for thirteen months. Zandomeneghi and Desboutin introduce him to Manet and his circle at the Café de la Nouvelle-Athènes. De Nittis is awarded a gold medal at the Exposition Universelle.

• **1879** The fourth Impressionist exhibition opens on 10 April. Degas exhibits twenty paintings and pastels and five fans. Invited by Degas, Zandomeneghi exhibits five works, including his portrait of Diego Martelli. The exhibition is reviewed by Martelli, who describes Degas as 'incontestably, one of the great French masters still alive'. Degas paints two portraits of Diego Martelli. Boldini exhibits for the first time at the Paris Salon.

• **1880** Diego Martelli sums up Degas's achievements in his lecture on Impressionism delivered to the Circolo Filologico of Livorno on 16 January. The fifth Impressionist exhibition opens on 1 April. Degas exhibits eight paintings and pastels, two groups of drawings, a group of prints and his sculpture of *The Little Dancer*. Zandomeneghi exhibits nine works, including *Mother and Daughter*.

• **1881** The sixth Impressionist exhibition opens on 2 April. Zandomeneghi is invited by Degas to participate for the second time. He exhibits five works. An exhibition of De Nittis's pastels is held at Le Cercle de l'Union Artistique in Paris.

• **1882** The seventh Impressionist exhibition opens on 1 March. Degas refuses to participate. Gauguin threatens to resign from the Société in protest against Degas's promotion of, among others, Raffaëlli, Zandomeneghi and De Nittis.

• **1883** De Nittis's *La Place du Carrousel: Ruins of the Tuileries in 1882* (Musée d'Orsay, Paris) is the first contemporary Italian painting to be bought by the State for the Musée du Luxembourg.

• **1884** Death at St Germain-en-Laye of De Nittis. Medardo Rosso spends a brief period in Paris until 1885.

• **1885** Medardo Rosso exhibits at the Salon.

• **1886** Degas makes a brief trip to Naples at the beginning of the year. The eighth Impressionist exhibition opens on 15 May. Degas exhibits only ten of the fifteen works listed in the catalogue. Once again, he invites Zandomeneghi to particpate. Medardo Rosso exhibits at the Salon des Indépendants.

• **1889** Boldini is awarded a 'grand prix' at the Exposition Universelle. Boldini and Degas travel together to Spain and Morocco. Rosso moves to Paris, where he remains until 1897.

• **1893** Zandomeneghi has first one-man exhibition at the prestigious Galerie Durand-Ruel in Paris. Medardo Rosso meets Rodin and swaps his *The Laughing Girl* for Rodin's *Torso*.

• **1897** Rosso leaves Paris.

ARTISTS' BIOGRAPHIES AND EXHIBITION CHECKLIST

Works marked with an asterisk* are reproduced as colour plates.

EDGAR DEGAS

Born in Paris on 19 July 1834
Died in Paris on 27 September 1917

Degas received a classical training in the studio of Louis Lamothe, a pupil of Ingres and attended the Ecole des Beaux-Arts in Paris from 1855–6. He travelled to Italy in 1856 and spent three years in the country. He travelled a great deal and devoted long hours to the study and copying of Italian Old Masters. In Florence he produced numerous preparatory drawings for his family portrait *The Bellelli Family* (Musée d'Orsay, Paris), which he completed in 1867.

Degas returned to Paris in April 1859 but made a further trip to Naples and Florence in 1860. In 1862 he met Manet and through him was introduced to the younger Impressionists at the Café Guerbois. During the 1860s he worked primarily on history painting and portraits, but in 1869 he expanded his repertoire, making wax sculptures of horses and, by 1870, painting his first images of the dancers and musicians of the Paris Opéra. In 1872 he travelled to

New Orleans, where his maternal uncle and two brothers were working in the cotton trade. In December 1873, back in Paris, Degas joined with Monet, Pissarro, Sisley, Morisot, Cézanne and others to form the Société Anonyme des Artistes, Peintres, Sculpteurs, Graveurs etc. He exhibited ten works at their first independent exhibition on 15 April 1874 at Nadar's studio. Despite the fact that he rarely painted 'en plein air' and refused to call himself an 'Impressionist', Degas participated in six of the remaining seven Impressionist exhibitions that took place between 1876 and 1886. During the 1870s he dedicated himself to the production of contemporary subjects, specialising in images of racehorses, dancers and café life. Influenced by Japanese prints he experimented with unusual viewpoints and asymmetrical compositions. He also began working in different media, especially printmaking, and between 1876 and 1881 more than two-thirds of his works in colour were executed in pastel on monotype. By the beginning of the 1880s Degas's career was well established and he was able to pick and choose his dealers. He became increasingly interested in depicting images of working women: milliners, laundresses, dancers and singers and in the latter part of his career he embarked on a series of pastels of women washing themselves. From the mid-1890s onwards he developed a richer palette and was more experimental in his technique. As he moved away from Realism towards Symbolism his work was admired by the younger generation of artists, including Gauguin and Odilon Redon.

Italian Landscape seen through an Arch, 1856 *
Oil on paper laid on canvas 37 × 32cm
Private Collection

Portrait of Adelchi Morbilli, c.1856–8
Pencil on paper 24.2 × 16.5cm
Private Collection, New York, through Jean-Luc Baroni Limited, London

Self-portrait with Floppy Hat, 1857 *
Oil on paper laid on canvas 26 × 19cm
Sterling and Francine Clark Art Institute, Williamstown, Massachusetts

View of Rome from the Tiber, c.1858 *
Oil on paper laid on canvas 18.1 × 26cm
The Langmatt Museum, Baden, Sidney and Jenny Brown Foundation

Castel dell'Ovo, c.1858–9 *
Oil on paper 18.1 × 26.2cm
The Langmatt Museum, Baden, Sidney and Jenny Brown Foundation

Portrait of a Woman (after a red chalk drawing attributed to Leonardo da Vinci), c.1858–9
Oil on canvas 64.7 × 45.4cm
National Gallery of Canada, Ottawa

Giulia Bellelli, Study for the Bellelli Family, c.1858–9 *
Essence and graphite on paper 36.2 × 24.8cm. Signed lower left: 'degas'
Dumbarton Oaks, House Collection, Washington DC

Edouard Manet, bust-length portrait, c.1864–6
Etching and drypoint on paper, 3rd state 12.5 × 10.5cm
Museo Pinacoteca Comunale Barletta

Manet Seated, Turned to the Right, c.1864–8 *
Etching and drypoint on white wove paper 1st state 19.4 × 12.9cm
National Gallery of Canada, Ottawa

Edmondo and Thérèse Morbilli, c.1865 *
Oil on canvas 116.5 × 88.3cm
Museum of Fine Arts, Boston, Gift of Robert Treat Paine II

Giovanna and Giulia Bellelli, 1865–6 *
Oil on canvas 92 × 73cm. Signed lower right: 'Degas'
Los Angeles County Museum of Art, Mr and Mrs George Gard De Sylva Collection

Double Portrait of the Montejasi Sisters,
*c.*1865–8 *
Oil on canvas 59.7 × 72.5cm
The Wadsworth Atheneum Museum of Art,
Hartford, Connecticut, The Ella Gallup Sumner
and Mary Catlin Sumner Collection Fund

*Jockey (The Red Cap), c.*1868–87 *
Oil on paper 43.7 × 30.6cm
Signed lower right: 'Degas'
Museum of Art, Rhode Island School of Design,
Providence, Gift of Mrs Murray S. Danforth

Lorenzo Pagans and Auguste de Gas,
*c.*1870–1
Oil on canvas 54.5 × 40cm
Musée d'Orsay, Paris, Gift of the Sociète des Amis
du Louvre, 1933

The Song Rehearsal, 1872–3 *
Oil on canvas 81 × 64.9cm
Dumbarton Oaks, House Collection,
Washington DC, Gift of Mildred and Robert
Woods Bliss

*Woman with Field Glasses, c.*1875–6 *
Oil on board 48 × 32cm. Signed twice, lower right
in white and ochre: 'Degas'
Galerie Neue Meister, Staatliche
Kunstsammlungen, Dresden

*Dancers in Red Skirts, c.*1876–84 *
Oil on canvas 38 × 44.5cm
Signed top right: 'Degas'
Ny Carlsberg Glyptotek, Copenhagen

Mlle Bécat at the Café des Ambassadeurs,
1877–8
Lithograph on paper 20.4 × 19.4cm
Museum of Fine Arts, Boston, Bequest of
W.G. Russell Allen

At the Theatre, Woman Seated in the Balcony,
*c.*1877–80 *
Oil on canvas 24.5 × 32.7cm
Signed lower right: 'Degas'
The Montreal Museum of Fine Arts, Gift of Mr
and Mrs Michael Hornstein

*The Singer, c.*1877–80 *
Pastel over monotype 15.9 × 11.4cm
Signed lower right: 'degas'
Courtesy of the Reading Public Museum
Reading, Pennsylvania

*Singer at the Café-Concert, c.*1878
Charcoal and white chalk on paper 47.5 × 31cm
Signed with studio stamp lower left: 'Degas'
Musée du Louvre, Paris, Département des Arts
Graphiques

Paul Lafond and Alphonse Cherfils
*Examining a Painting, c.*1878–81
Oil on panel 26.8 × 34cm. Signed bottom left and
inscribed: 'Degas / a ses chers amis'
Cleveland Museum of Art, Cleveland, Bequest of
Leonard C. Hanna, Jr

Diego Martelli, 1879 *
Oil on canvas 110.4 × 99.8cm. Signed with studio
stamp lower right: 'Degas'
National Gallery of Scotland, Edinburgh

Diego Martelli, 1879
Charcoal and white chalk 44 × 32.3cm
Cleveland Museum of Art, John L. Severance
Fund, 1953

Portraits in a Frieze, 1879
Black chalk and pastel on grey paper
49.4 × 64.5cm. Signed lower right: 'Degas' and
inscribed: 'portaits en frise pour décoration dans
un appartement'
Stephen Mazoh

*The Dance Examination, c.*1879 *
Pastel and charcoal on paper 63.4 × 48.2cm.
Signed lower right: 'Degas'
Denver Art Museum, Anonymous Gift

Mary Cassatt at the Louvre: The Paintings
*Gallery, c.*1879–80 *
Etching, softground etching, aquatint and
drypoint on cream laid paper 5th state
30.3 × 12.7cm
Museum of Fine Arts, Boston, Katherine E.
Bullard Fund in memory of Francis Bullard

*Before the Start, c.*1880–90 *
Oil on canvas 39 × 89cm
Signed lower left: 'Degas'
Foundation E.G. Bührle Collection, Zurich

Head Leaning on Hand, 1882 *
Bronze from original in plaster and other
materials 12.3 × 17.5 × 16.2cm
Musée d'Orsay, Paris; acquired through the
generosity of the artist's descendants and the
Hébrard family, 1930

Jockeys on Horseback before Distant Hills,
1884
Oil on canvas 44.9 × 54.9cm
The Detroit Institute of Arts, Gift of W. Warren
and Virginia Shelden in memory of Mrs Allan
Shelden

Woman Viewed from Behind, 1885
Oil on canvas 81.3 × 75.6cm
National Gallery of Art, Washington DC,
Collection of Mr and Mrs Paul Mellon

*The Tub, c.*1888–9 *
Bronze from an original in wax, lead and plaster
22 × 45.7 × 42cm
National Gallery of Scotland, Edinburgh

*Rearing Horse, c.*1888–90 *
Bronze from wax original 27.5 × 41 × 24.5cm
Paris, Musée d'Orsay, acquired through the
generosity of the artist's descendants and the
Hébrard family, 1930

*Portrait of Boldini, c.*1889
Charcoal drawing on paper 68 × 50cm
Museo Giovanni Boldini, Ferrara

*Le Cap Hornu, c.*1890 *
Monotype on paper 29.9 × 40cm
The British Museum, London

*Twilight in the Pyrenees, c.*1890
Monotype on paper 28.6 × 38.8cm
Ackland Art Museum, the University of North
Carolina at Chapel Hill, Ackland Fund

Landscape with Rocks, 1892
Pastel over monotype in oil colours on white wove
paper 25.7 × 34.6cm
High Museum of Art, Atlanta

*Landscape by the Sea, c.*1892 *
Monotype and pastel on paper 27 × 36cm. Signed
lower right and inscribed: 'à M. Charpentier/
Degas'
Musée d'Art et d'Histoire, Neuchâtel

*Portait of Rose Caron, c.*1892 *

Oil on canvas 76.2 × 82.6cm
Signed lower left: 'Degas'
Albright-Knox Art Gallery, Buffalo, New York,
Charles Clifton, Charles W. Goodyear and
Elisabeth H. Gates Funds, 1943

*Head. Second study for the portrait of Mlle
Mathilde Salle,* 1892

Bronze from a terracotta original
24 × 15.6 × 20.8cm. Signed on neck: 'Degas'
Musée d'Orsay, Paris, acquired through the
generosity of the artist's descendants and the
Hébrard family, 1930

*Arabesque penchée (wrongly called Grand
Arabesque), c.*1892–6 *

Bronze from original in brown wax
40.3 × 63 × 31cm
National Gallery of Scotland, Edinburgh

Dancer with Fan, 1894 *

Pastel on paper 47 × 62cm
Signed lower left: 'Degas'
Private Collection, London

*'La Masseuse', c.*1895 *

Bronze from original in brown plastilina
43.2 × 36.5 × 42.5cm
Musée d'Orsay, Paris acquired through the
generosity of the artist's descendants and the
Hébrard family, 1930

*Seated Woman Drying her Neck, c.*1895–6 *

Bronze from wax original 32.5 × 26 × 30cm
Musée d'Orsay, Paris, acquired through the
generosity of the artist's descendants and the
Hébrard family, 1930

*Before the Performance, c.*1895–1900 *

Oil on paper, laid on canvas 47.6 × 62.5cm
Signed with studio stamp lower right: 'Degas'
National Gallery of Scotland, Edinburgh

La Coiffure, after 1896 *

Oil on canvas 82 × 87cm
Signed lower right: 'Degas'
Nationalgalerie, Oslo

*A Group of Dancers, c.*1898 *

Oil on paper, laid on canvas 47 × 61.9cm
Signed with studio stamp lower left: 'Degas'
National Gallery of Scotland, Edinburgh

*Woman Washing her Left Leg, c.*1899

Bronze from wax original 15.2 × 12.2 × 15.5cm
Musée d'Orsay, Paris, acquired through the
generosity of the artist's descendants and the
Hébrard family, 1930

*After the Bath, c.*1899–1905 *

Pastel on tracing paper 80 × 58.4cm
Signed lower left: 'Degas'
Columbus Museum of Art, Ohio, Gift of
Ferdinand Howald

*Seated Bather Drying her Neck, c.*1900–5 *

Pastel on two sheets of paper laid on board
68.7 × 58.1cm. Signed lower left: 'Degas'
Fine Arts Museums of San Francisco, Achenbach
Foundation for Graphic Arts, Gift of Mrs John
Jay Ide

*Woman Drying her Hair, c.*1903–5

Charcoal and Pastel on tracing paper 77 × 75cm
Signed lower left: 'Degas'
Musée Cantonal des Beaux-Arts, Lausanne,
Bequest of Henri-Auguste Widmer, 1939

FEDERICO ZANDOMENEGHI

Born in Venice on 2 June 1841
Died in Paris on 30 December 1917

Zandomeneghi studied at the Accademia
di Belle Arti in Venice but left the city in
1859 to escape conscription. He enrolled at
the University of Pavia and the following
year supported Garibaldi in the Expedition
of the Thousand. Convicted of desertion
he was unable to return to Venice, and
moved to Florence, where he mixed with
the group of artists known as the Macchi-
aioli. He was especially close to Telemaco
Signorini and the critic Diego Martelli,
who remained a lifelong friend. He re-
turned to Venice in 1872 and in 1874,
probably encouraged by Martelli, left for
Paris, where he eventually settled. In Paris
'Zandò', as he was known, became friends
with Degas, Renoir, Manet and later
Toulouse-Lautrec. In 1879 he exhibited his

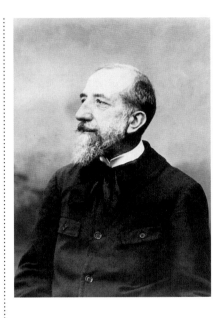

portrait of Diego Martelli in the fourth
Impressionist exhibition. He also participat-
ed in the fifth, sixth and eighth Impression-
ist exhibitions. However, despite the
patronage of the dealer Paul Durand-Ruel,
his main source of income at this time was
from producing drawings for a fashion
magazine. From the mid-1880s onwards
Zandomeneghi began experimenting with
pastel. He moved away from Impressionism,
adopting a form of divisionism character-
ised by brilliant colour and vibrant webs or
threads of light. His pictures of the 1890s
are comparable with Renoir's early style
and like Renoir he produced numerous
images of young women. By this date Zan-
domeneghi was receiving a certain amount
of recognition and in 1893 Durand-Ruel
gave him his first one-man show. Neverthe-
less, he was a pessimist by nature and
towards the end of his life he shut himself
away in his studio where he produced
numerous still lifes of fruit and flowers.

Mother and Daughter, 1879 *
Oil on canvas 62 × 52cm
Signed lower right: 'FZandomeneghi'
Matteucci Institute, Viareggio

The Cellist, 1879–80
Oil on canvas 82 × 72cm
Signed upper right: 'FZandomeneghi'
Private Collection, Lecco

At the Café, 1884 *
Oil on canvas 65 × 55cm. Signed and dated
lower right: 'FZandomeneghi 84'
Museo Civico di Palazzo Te, Mantua

The Singing Lesson, c.1885–90
Oil on canvas 65 × 54.5cm
Signed lower left: 'FZandomeneghi'
Banca Intesa Collection, Milan

Theatre Box, 1885–95 *
Oil on canvas 71 × 88cm
Signed lower left: 'Zandomeneghi'
Matteucci Collection, Viareggio

The Bedroom, c.1886 *
Pastel on paper 35.9 × 29cm. Studio stamp,
lower right
Edmondo Sacerdoti, Milan

Woman Drying Herself, c.1886–98 *
Pastel on paper 45 × 37cm
Signed lower right: 'FZandomeneghi'
Edmondo Sacerdoti, Milan

The Tub, c.1886–1900 *
Oil on canvas 55 × 65cm. Signed lower right:
'FZandomeneghi'
Edmondo Sacerdoti, Milan

Waiting (copy after Degas), 1893–4 *
Pastel on paper 49 × 62cm. Signed lower right:
'FZandomeneghi/d'après Degas'
Durand-Ruel et Cie, Paris

Female Nude at the Mirror, c.1893–1900
Pastel on paper 70 × 40cm
Signed lower right: 'FZandomeneghi'
Edmondo Sacerdoti, Milan

The Awakening, 1895 *
Pastel on paper glued on card and plywood
60 × 72cm. Signed and dated lower left:
'FZandomeneghi/95'
Museo Civico di Palazzo Te, Mantua

Paul-Albert Bartholomé (1848–1928)
Federico Zandomeneghi, 1890
Plaster bust 56 × 25 × 21cm. Signed and dated
on back: 'Abartholomé/1890'
Musée d'Orsay, Paris

GIUSEPPE DE NITTIS

Born in Barletta, Puglia, on 25 February 1846
Died at Saint-Germain-en-Laye, near Paris,
on 21 August 1884

Like Degas, De Nittis worked in several
media, including oils, watercolours and
printmaking, and played a major part in
the pastel revival. Unlike Degas, he was
committed to the plein-air aesthetic and
this, together with his interest in the effects
of light, brought him in contact with the
Impressionists. He also had an important
influence on the Macchiaioli, especially
Telemaco Signorini.

De Nittis attended the Istituto di Belle
Arti in Naples from January 1862 to June
1863 but was expelled for rebelling against

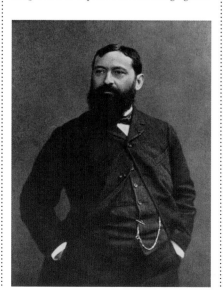

the academic teaching methods. Along
with Marco De Gregorio and Federico
Rossano he formed the Scuola Resina, a
group of artists dedicated to the direct
representation of nature, and strongly
influenced by the Florentine artist Adriano
Cecioni.

In 1867 De Nittis travelled to Paris. The
following year, having signed a contract
with the dealer Reitlinger, he settled there
permanently and married a French woman,
Léontine Lucile Gruvelle. At the outbreak
of the Franco-Prussian war he returned to
Naples and Barletta and witnessed the
eruption of Vesuvius in April 1872. He
produced a number of picturesque views
of the volcano for the Paris dealer Adolphe
Goupil, as well as numerous small sketches.

Back in Paris De Nittis developed close
friendships with Degas, Manet, Caillebotte
and Desboutin. He was extremely gregari-
ous and entertained a wide circle of artists,
writers and art critics at his Saturday
soirées. In 1873 he began experimenting
with printmaking, producing a number of
etchings, drypoints and lithographs. He
also painted several views of Paris, often
depicting elegant women walking or riding
in the open air. In 1874, invited by Degas,
he took part in the first Impressionist exhi-
bition. However, representing the more
'acceptable' face of Impressionism, he was
not welcomed by most of the younger
Impressionists, especially Renoir, and did
not participate in any of the later exhibi-
tions. By the late 1870s De Nittis had
achieved an international reputation and
was well known in London as well as Paris.
He was awarded a gold medal at the 1878
Exposition Universelle and soon after
received the Légion d'honneur. In 1883 his
picture *La Place du Carrousel: Ruins of the
Tuileries in 1882* (Musée d'Orsay, Paris) was
the first contemporary Italian painting to be
bought by the State for the Musée du
Luxembourg.

*Vesuvius from Torre Annunziata,*1872 *
Oil on panel 18.5 × 31cm
Signed and dated lower right: 'De Nittis 72'
Private Collection, Valdagno

Mountainous Landscape in Italy (Vesuvius),
*c.*1872 *
Oil on panel 14 × 25cm
Signed lower right: 'De Nittis'
Private Collection, Valdagno

*The Crater, Vesuvius, c.*1872 *
Oil on panel 18.5 × 31cm
Signed lower left: 'De Nittis'
Private Collection, Valdagno

Portrait of Edgar Degas in Profile,
20 February, 1875
Drypoint on paper 8.5 × 7cm
Museo Pinacoteca Comunale, Barletta,
De Nittis Bequest

*The Alcove, c.*1878–80 *
Watercolour on paper 16 × 22cm
Signed lower right: 'De Nittis'
Museo Pinacoteca Comunale, Barletta,
De Nittis Bequest

*Landscape, c.*1878–80
Monotype on paper 16 × 23.7cm
Museo Pinacoteca Comunale, Barletta,
De Nittis Bequest

Racing at Longchamp, 1883 *
Oil on canvas 80 × 117cm
Museo Pinacoteca Comunale, Barletta,
De Nittis Bequest

At the Races, Auteuil, 1883 *
Oil on canvas 107.5 × 57cm
Signed and dated lower right: 'De Nittis 83'
Museo Pinacoteca Comunale, Barletta,
De Nittis Bequest

In the Salon (Study for the Salon of the
*Princess Mathilde), c.*1883 *
Oil on canvas 62.5 × 45cm
Museo Pinacoteca Comunale, Barletta,
De Nittis Bequest

*Self-portrait, c.*1883
Pastel 114 × 88cm. Inscribed lower right:
'Certifié du J. de Nittis / Line de Nittis / 1884'
Museo Pinacoteca Comunale, Barletta,
De Nittis Bequest

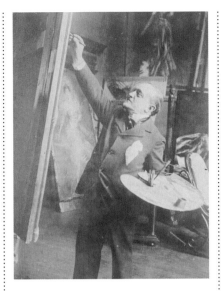

GIOVANNI BOLDINI

Born in Ferrara on 31 December 1842
Died in Paris on 11 January 1931

Boldini received lessons in painting from his father, the painter Antonio Boldini and was already an accomplished portrait painter by the age of eighteen. In 1862 he moved to Florence, where he attended the Scuola del Nudo at the Accademia di Belle. He also frequented the Caffè Michelangiolo, the regular meeting place of the Macchiaioli. Under their influence he produced a number of landscapes, but he preferred portraiture and played an important part in the development of this genre. He associated with the wealthier and more sophisticated members of the group, including the portrait painter Michele Gordigliani (who introduced him to potential sitters), Telemacho Signorini and Cristiano Banti.

In 1867 Boldini visited the Exposition Universelle in Paris and four years later he moved to France for good. He was con-

tracted to the dealer Adolphe Goupil, for whom he produced a series of landscapes, genre subjects and views of Parisian life that proved extremely popular. In 1874 he exhibited for the first time at the Salon. Two years later he travelled to Germany, where he met and was inspired by Adolph Menzel. He also visited the Netherlands, where he encountered the work of Frans Hals. It was around this time that he began painting portraits of society women, characterised by their carefully detailed and brightly lit faces, contrasting with their more freely painted costumes and surroundings. In the 1880s, perhaps influenced by Degas, he began working in pastel, often for full-scale portraits and in 1889 he accompanied Degas to Spain (where he admired the work of Velázquez) and Morocco. By the 1890s he was sought after by society beauties and celebrities and, along with Sargent, was one of the most popular portrait painters in fin-de-siècle France. By this date he had developed his mature style, distinctive for its swift, fluid brushwork and exaggerated movements. From 1900 onwards his style became more frenetic, and he introduced unusual viewpoints and awkward poses, prefiguring the dynamism of Futurism. Boldini continued to produce portraits until the end of his life, but after 1916, with failing eyesight, he limited himself to charcoal drawings.

*Portrait of Edgar Degas c.*1876–80 *
Etching and drypoint on paper 20 × 14.9cm
Museo Giovanni Boldini, Ferrara

*Dance Step, c.*1880–90 *
Pencil on paper 36.6 × 26.4cm
Museo Giovanni Boldini, Ferrara

The Maestro Emanuele Muzio on the Podium,
1882 *
Oil on panel 27 × 22cm. Inscribed upper left:
'All'amico maestro Muzio / Boldini'
Casa di Riposo per Musicisti, Giuseppe Verdi
Foundation, Milan

*The Cabaret Singer, c.1884 ***
Oil on canvas 61 × 46cm
Private Collection

Connoisseurs in an Artist's Studio, c.1885–90
Oil on panel 35 × 26.8cm
Private Collection through Jean-Luc Baroni, London

Figure in a Salon (Musical Evening), c.1885–95
Pencil on paper 17.5 × 11.5cm
Museo Giovanni Boldini, Ferrara

Spectators at the Theatre, c.1897
Pastel on paper 49.5 × 66cm
Museo Giovanni Boldini, Ferrara

*Study for 'The Red Café', 1887 ***
Oil on panel 77.5 × 99.1cm
Fine Arts Museums of San Francisco, Gift of Whitney Warren Jr in memory of Mrs Adolph B. Spreckels

*Woman in Black Looking at the Pastel of Emiliana Concha de Ossa, c.1888 ***
Oil on panel 80.5 × 64.5cm
Museo Giovanni Boldini, Ferrara

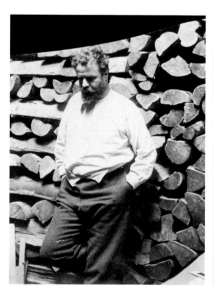

Portrait of Edgar Degas, c.1895
Charcoal on canvas 60.5 × 46cm
Studio stamp lower right: 'Boldini'
Museo Giovanni Boldini, Ferrara

Portrait of Whistler Sleeping, c.1897
Drypoint on paper 19.9 × 29.9cm
Museo Giovanni Boldini, Ferrara

Portrait of Paul Helleu
Lithograph on Chinese paper, laid on card 39.9 × 32.8cm
Signed on lithographic stone, lower right: 'Boldini'
Museo Giovanni Boldini, Ferrara

MEDARDO ROSSO

Born in Turin on 21 June 1858
Died in Milan on 31 March 1928

Medardo Rosso trained at the Accademia di Belle Arti di Brera in Milan but, like De Nittis, was expelled in 1883 for protesting against their traditional teaching methods. He rejected the academic emphasis on historical themes, in favour of contemporary subjects and the portrayal of 'ordinary' people. Such ideas were fostered by contact with Gli Scapigliati, a group of left-wing avant-garde artists and writers dedicated to naturalism. Rosso was interested in creating a crossover between sculpture and painting. He was fascinated by the way in which light could transform or 'dematerialise' a solid object and this is exemplified in *Impression of an Omnibus* (1883–4; destroyed) which portrays five figures and their surroundings fused together in a single 'impression'.

Rosso exhibited at the Salon des Champs Elysées in 1885 and at the Salon des Indépendants in 1886. Three years later he moved to Paris, where he lived until 1910. Shortly after his arrival in the capital he met the writer and art critic Emile Zola who bought one of his sculptures, *The Concierge*. In the same year he

met the major Impressionist collector Henri Rouart who commissioned a portrait of himself, thus establishing Rosso's position in the Parisian art world.

During this period Rosso became interested in capturing the changing mood of the sitter, as in *The Laughing Girl* of 1890. He also pursued his interest in the relationship between a figure and its surroundings, producing plein-air-type 'impressions' such as *Conversation in the Garden*. From 1893 onwards Rosso developed a close friendship with Auguste Rodin, swapping his *Laughing Girl* for Rodin's bronze *Torso*.

During the 1900s Rosso's work was exhibited widely, in the Netherlands, Berlin, Leipzig, Vienna, Paris and London. It was in London that he completed his last sculpture, *Ecce Puer*, which moves into the realms of Symbolism. From 1908 onwards Rosso was promoted in Italy by the critic and painter Ardengo Soffici and later by the art critic Margherita Sarfatti. His work – especially his concern for the dynamic relationship of solid forms to their surroundings – had an important impact on the Italian Futurists.

*The Laughing Girl, 1890 ***
Bronze 35 × 20 × 26cm
Inscribed on front: 'M. Rosso 1893 / à Rodin'
Musée Rodin, Paris

*Conversation in the Garden, 1896 ***
Bronze 31.5 × 66.5 × 38cm
Galleria Nazionale d'Arte Moderna, Rome

Ecce Puer (Behold the Boy), 1906
Plaster, gesso and varnish 46.2 × 43 × 32cm
Scottish National Gallery of Modern Art, Edinburgh

*Ecce Puer (Behold the Boy), 1906 ***
Bronze 44 × 37 × 27cm
Musée d'Orsay, Paris